IMAGES
of America

MAINE LODGES AND SPORTING CAMPS

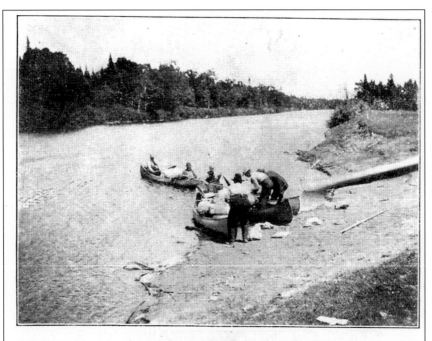

Maine Central Railroad

Prior to the road network of today and airplane travel, most travel from the cities and points south occurred by rail. Several railroads took full advantage of Maine's sporting potential, establishing rail lines and advertising extensively to promote the region. (*In the Maine Woods*, 1906.)

IMAGES
of America

MAINE LODGES AND SPORTING CAMPS

Donald A. Wilson

ARCADIA

On the cover: Three waitresses pose at the dining room of the West Outlet Camps while awaiting guests to be served.

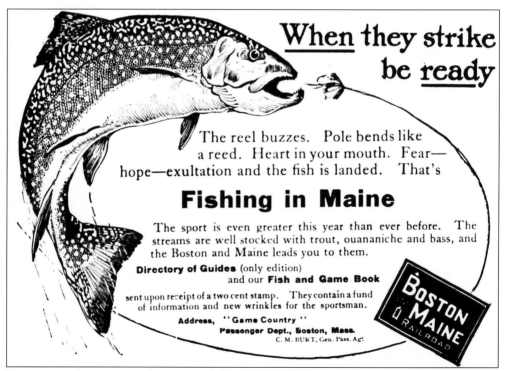

Here is an advertisement from one of the popular sporting magazines of the era. Railroad advertisements were in abundance in an attempt to appeal to the sporting community.

CONTENTS

ACKNOWLEDGMENTS

Sincere appreciation goes to the Bangor and Aroostook Rail Company, who granted permission to use selections of text as well as advertisements from their publications, *In the Maine Woods*, which was published annually for six decades. Thanks to their efforts, the Maine sporting tradition and many of its sporting facilities have been documented and preserved for future generations.

Donald A. Wilson's other Arcadia titles include *Glimpses of Maine's Angling Past, Maine's Hunting Past*, and *Logging and Lumbering in Maine*.

Dedicated to the individuals and the families of the sporting tradition in the state of Maine, especially those who have persevered through several generations. Thanks to you, it is possible to visit Maine, stay awhile, and enjoy its outdoor resources and beauty.

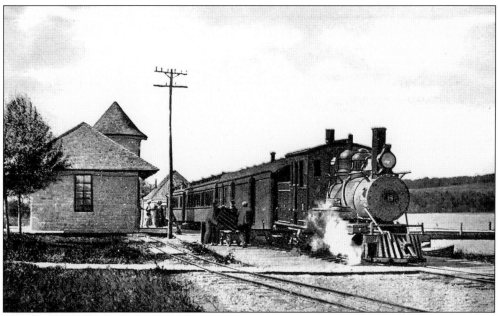

This train from the narrow-gauge Sandy River Railroad waits at the Rangeley Station while passengers load and unload.

INTRODUCTION

According to Webster's dictionary, a lodge is defined as a house set apart for residence in the hunting or other special season. During the 19th and 20th centuries, there were many such facilities established in Maine, and although they are now mostly gone, a few remain in the old tradition. This book focus mainly, though not quite entirely, on those lodges and sporting establishments that are no longer in existence, at least not as they were in their heyday.

The early part of the last century witnessed the height of the boom in sporting endeavors for Maine, and also for the Adirondacks of New York, and to a lesser extent, in New Hampshire and Vermont. The wilderness of New England was a haven for the sportsman with an abundance of fish and game. Some of the more elaborate resorts were not limited to the pursuit of game and fish, even though they heavily relied on the natural resources. Other activities were offered as well, such as golfing, boating, horseback riding, and a variety of other attractions. Many of these activities attracted wealthy families from places such as Boston, New York, Philadelphia, and other metropolitan areas. Interestingly, Maine had a number of visitors from Europe, despite the difficulty of the journey.

After leaving the train on arrival in Maine, travelers either boarded a steamer to go to a lake destination, or they rode in a stagecoach or other wheeled conveyance to get to an inland location. Depending on the final destination, this part of the journey could be long and arduous; however, it was necessary and a part of the overall experience. Many lodges had their own boats or other form of transportation.

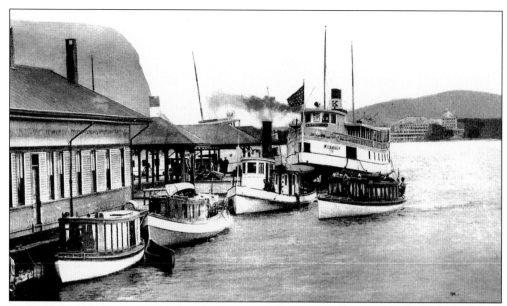

At Moosehead Lake, commercial and private steamboats meet the train at the Kineo terminal of the Somerset Branch of the Maine Central Railroad. These boats transported sportsmen and vacationers to their respective resorts.

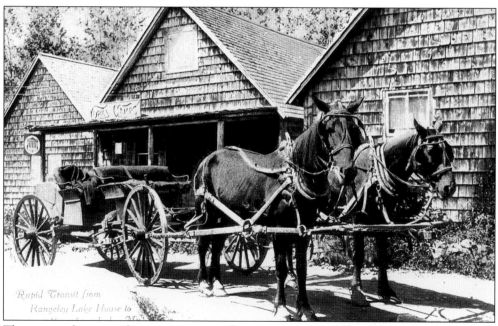

The wagon shown in this picture was used to transport guests from the railroad station in Rangeley to points inland. Here, it is parked in front of York's Camps at Kennebago Lake.

One

NORTHERN MAINE

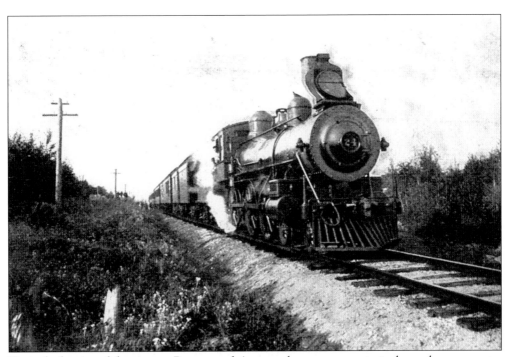

Typical of trains of the time, a Bangor and Aroostook passenger train is shown here en route. The company advertised heavily. One advertisement read, "To Bed in Boston—AWAKE IN AROOSTOOK. 'Travel by train' and you can go to bed in your through sleeping-car in Boston and awake in the heart of the Aroostook County. The Bangor & Aroostook Railroad provides quick and comfortable service to all Maine Woods points."

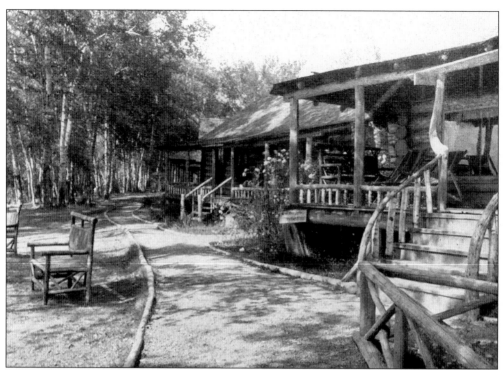

Eagle Lake Camps were located on the Fish River Chain six miles from Eagle Lake Village. The dining cabin and office are shown here, with cottages seen in the background.

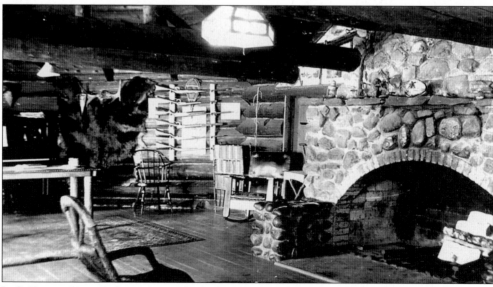

L. S. Titus, a New York sportsman, built the camps, and they were advertised as "the finest and most beautiful set of log cabins in the State of Maine." This office and lounge area attest to their construction.

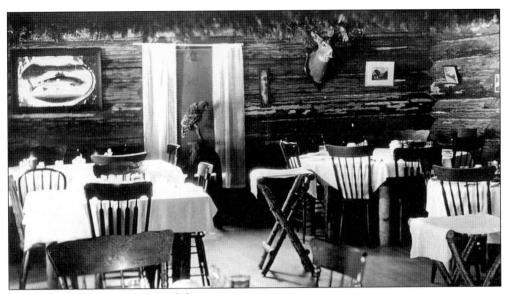

Meals were served in the central dining room.

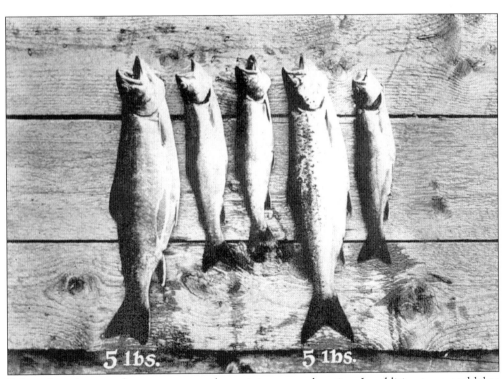

Fishing for salmon and trout was a popular activity, as was hunting. In addition to several lakes and many streams in the vicinity, the Eagle Lake Camps were surrounded by many square miles of wilderness.

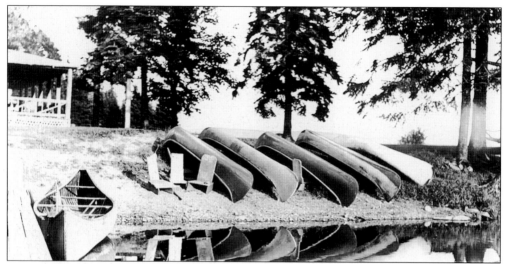

C. H. Fraser's Inlet Camps were located on the north shore of Square Lake in the Fish River Chain. Cottages, 11 of them in 1917, were built of peeled logs and contained porches. Rooms were heated with open fire or plain wood stoves, and the dining camp had separate tables for each party.

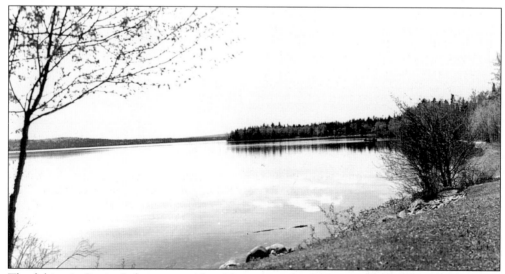

The fishing in Square Lake was considered by many to be the best available. Fraser's, like many sporting camps in Maine, was blessed with a beautiful view, as shown in this photograph.

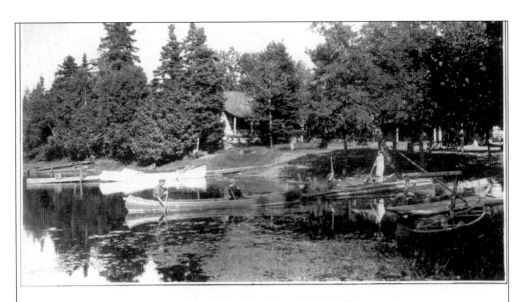

INLET CAMPS AND COTTAGES
Maine's Greatest Salmon Lakes
The Fish River Chain

FOR A REAL WOODS VACATION

There's no finer place than

INLET CAMPS

ON SQUARE LAKE

Farthest North of any Sporting Camps in the United States

FISHING that makes glad the angler's heart may be enjoyed on famous Square Lake and on seven other connecting waters — all renowned for the fine sport they offer. Trout, salmon and togue. Good fly fishing in May and September. Salmon pool at the camps.

HUNTING that cannot be beaten in all the Aroostook country can be had in the great game section surrounding the Inlet Camps location. Deer and bear for the big game devotee and the best of partridge and duck shooting for the gunner.

Amusements, Obstacle Golf, Tennis and Croquet
There is no finer vacation spot in all the Maine Woods than at Inlet Camps
Flush toilets and private baths

There is an unusual opportunity for canoeing and the Thoroughfare between Square and Cross Lakes is especially favorable for women and amateurs. Of course our table is good, and we make it our business to give everybody a good time. Our satisfied patrons say we are successful.

Our Booklet Gives Detailed Information

C. H. FRASER, Square Lake, GUERETTE, ME.

This advertisement describes fishing and hunting in great detail. (*In the Maine Woods*, 1931.)

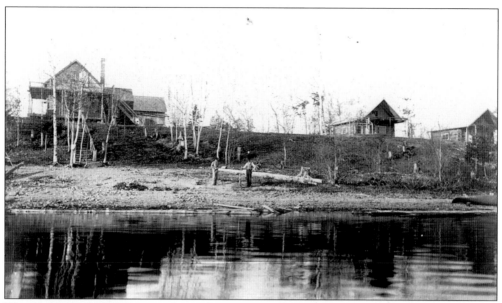

The Hook Point Camps were located on Mattawamkeag Lake in Island Falls. They were operated by William Wingate Sewall, a personal friend of Pres. Theodore Roosevelt.

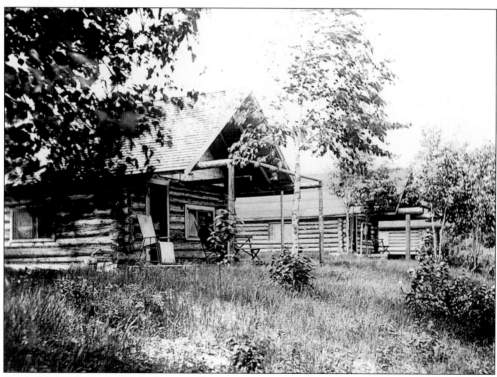

Several log cabins are shown here in their rustic setting.

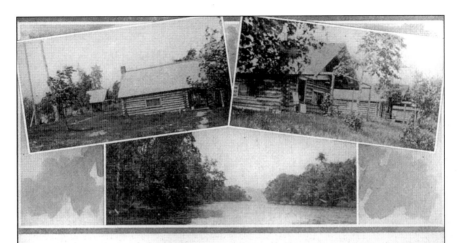

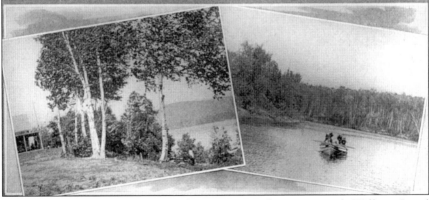

When Teddy Roosevelt was a youngster, he spent several summers with William Sewall, who taught him about the outdoors, as well as hunting and fishing. (*In the Maine Woods*, 1911.)

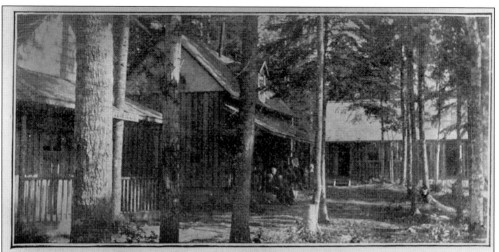

Birch Point Lodge

On Upper Shinn Pond, 12 miles from Patten, over excellent road. You can come to within three miles of camp by automobile. Our camps and table fare are unexcelled. Fly-fishing for trout and landlocked salmon holds good all summer. The camps are on a high point almost surrounded by water so there is always a cool breeze and flies and mosquitoes are a rarity.

Six out-lying camps offer our guests unexcelled moose, deer and bear hunting. Boats and canoes are free and experienced guides are furnished. For rest or sport our camps are unexcelled.

Rates $2.00 per day or $10.00 per week. Private cabins most comfortably furnished, open fires. $14.00 per week. Write for circular and references.

W. S. McKenney, Patten, Maine

Birch Point Lodge, like many of the resorts, advertised outlying facilities where sports could fish and hunt away from the main facility. (*In the Maine Woods*, 1911.)

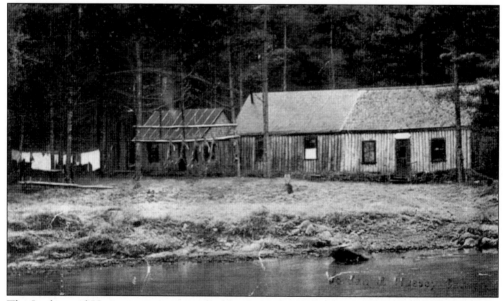

The Jordan and Hussey camp was reached by canoe from the Seboeis station on the Canadian Pacific Railroad. It had a main camp that accommodated 20 people, and a cottage was reserved for wives and daughters of the patrons. It was almost exclusively a hunting camp.

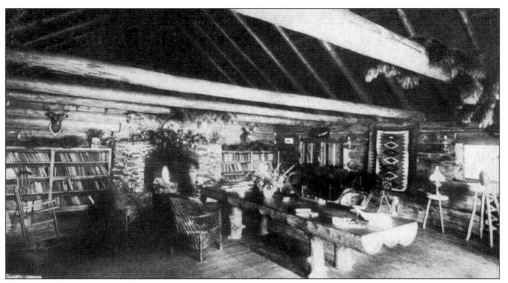

Point of Pines Camps, operated by G. F. Root, was located on Upper Shin Lake in Patten. The site was known for excellent fishing and hunting. The recreation cabin shown here provided sports entertainment and relaxation apart from the individual cottages.

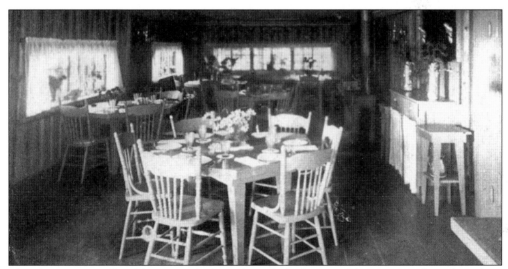

The dining area offered home-cooked meals with fresh vegetables, eggs, and produce from neighboring farms. This camp could accommodate up to 40 people.

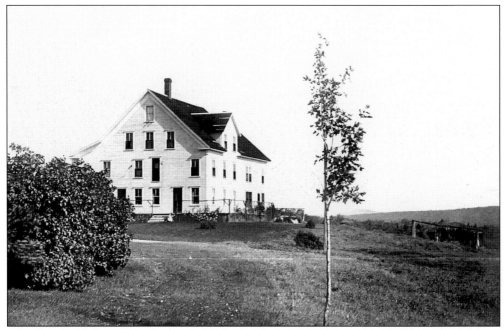

The Shin Pond House was also located in Patten, between Upper and Lower Shin Ponds. It was famous for trout and salmon fishing, and it held the record for game shipment for many years. Patrons arrived at the camp by stage line from Patten.

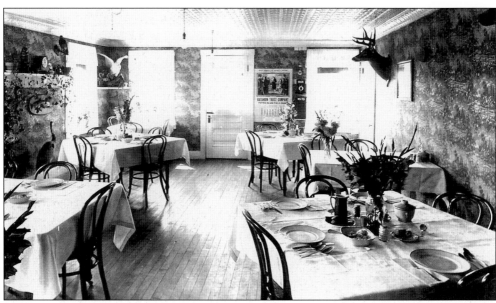

The dining room at the Shin Pond House advertised excellent food that was well prepared and served. Fresh vegetables, milk, cream, butter, eggs, and poultry all came from their own farm.

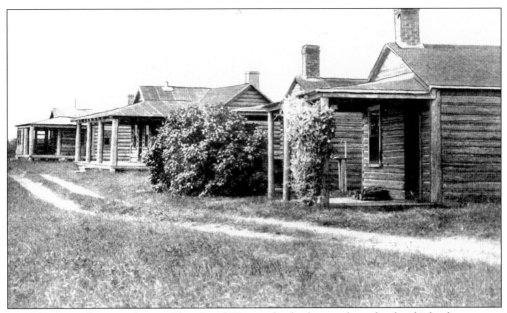

In addition to the main house, Shin Pond House also had a number of individual cabins, some of which are shown here.

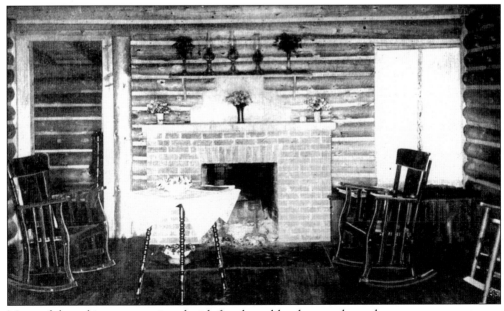

Many of the cabins were equipped with fireplaces like the one shown here.

Sawtelle Brook Camps

In the heart of a region famous for its big game—moose, deer and bear—and for its trout and salmon fishing. Twenty-one miles in from Patten, by buckboard, over good roads Within easy canoeing reach, through deadwater, are Hay and Scraggly lakes and Mud and Sawtelle ponds. Camps are well furnished and fully equipped for comfort and convenience. Mail every other day.

Stevie Giles & Pearlie Joy **Patten, Maine**

The Sawtelle Brook Camps were also located in the Patten area, and they were accessible by buckboard in town. (*In the Maine Woods*, 1912.)

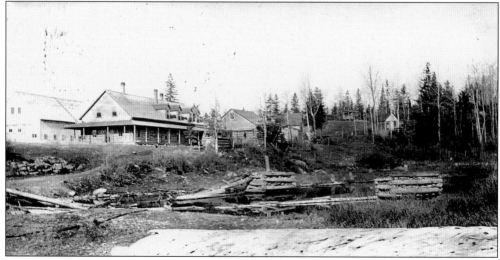

The Sebois Bridge Camps, also located in the Patten area, opened in 1913. They advertised that they were "in the heart of the supreme game country."

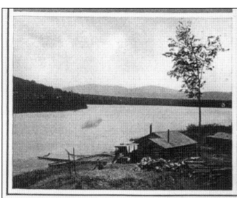
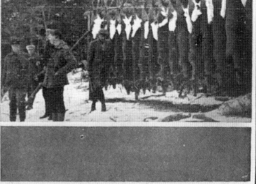

The Patten area was very popular with sportsmen, and therefore it supported a number of sporting establishments in a relatively small area. Game was very much in abundance, and fishing was excellent. (*In the Maine Woods*, 1913.)

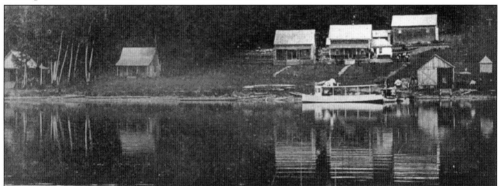

Camp Iverson was located at Portage Lake, north of Patten and south of the Fish River Chain. It was a relatively small establishment, but it was a classy operation nonetheless. (*In the Maine Woods*, 1913.)

21

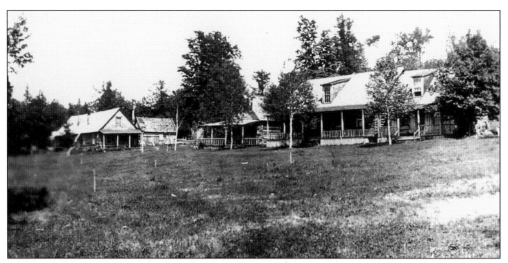

The Square Lake Camps were founded *c.* 1912, and they were operated for many years by Jack Yerxa and his wife, Jennie, until Jack's death in 1950. The camps were a favorite gathering place for outdoor writers' groups, and they were popular with Maine dignitaries, including Gov. Lucius Barrows, who was a regular.

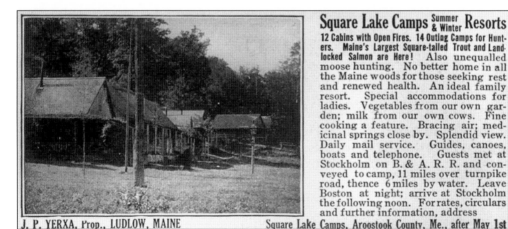

Square Lake Camps Summer & Winter **Resorts**

12 Cabins with Open Fires. 14 Outing Camps for Hunters. Maine's Largest Square-tailed Trout and Landlocked Salmon are Here! Also unequalled moose hunting. No better home in all the Maine woods for those seeking rest and renewed health. An ideal family resort. Special accommodations for ladies. Vegetables from our own garden; milk from our own cows. Fine cooking a feature. Bracing air; medicinal springs close by. Splendid view. Daily mail service. Guides, canoes, boats and telephone. Guests met at Stockholm on B. & A. R. R. and conveyed to camp, 11 miles over turnpike road, thence 6 miles by water. Leave Boston at night; arrive at Stockholm the following noon. For rates, circulars and further information, address

J. P. YERXA, Prop., LUDLOW, MAINE Square Lake Camps, Aroostook County, Me., after May 1st

This advertisement describes the details of the Square Lake Camps. The lake was widely famous for its large salmon, and the area was known for abundant game. (*In the Maine Woods*, 1915.)

Two
Central Maine

Jap Haynes, from the Buck Horn Camp in Norcross, poles his canoe up the West Branch of the Penobscot River.

Camp Moosehorns was located on Little Seboeis Lake, just northeast of Brownville Junction. This guide is checking the canoes, the favored mode of travel for the small waters that occur in this area.

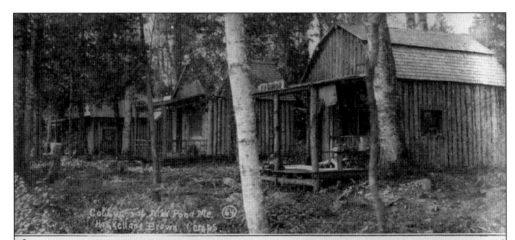

Fourteen cottages, such as the ones shown here, made up Camp Moosehorns. One of its selling points was the ease of accessibility from the Bangor and Aroostook Railroad, even though a short journey by canoe was necessary. (*In the Maine Woods*, 1913.)

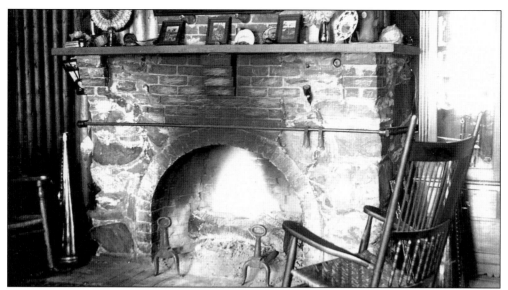

The Lakeside Camps, operated by N. W. McNaughton, were located on Schoodic Lake, famous for its large lake trout. This photograph shows one of the large fireplaces found here.

This camp operated a sizeable dining area, and it advertised an "unsurpassed table."

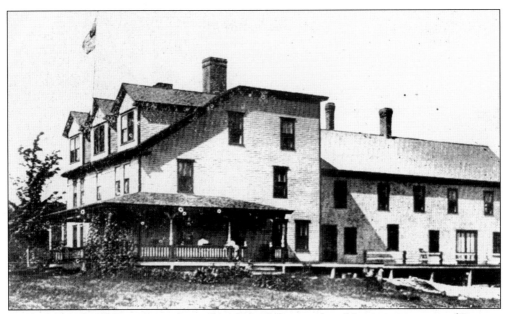

Turner's Hotel and Camps were located on Lake Sebasticook in Newport, just west of Bangor. The Turner House, shown here, was located on the shore of the lake.

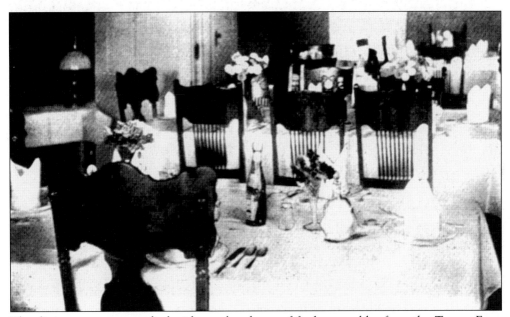

The dining room was supplied with an abundance of fresh vegetables from the Turner Farm along with rich, pure milk. Fish could be ordered at any time.

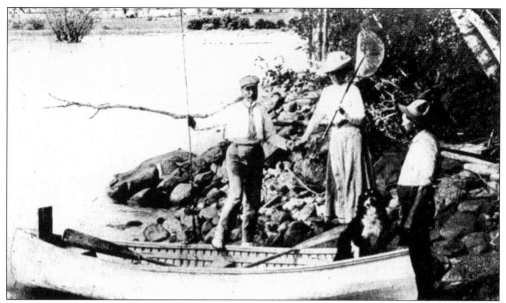

While hunting was available here, the emphasis was on fishing. At one time, Lake Sebasticook offered salmon, bass, pickerel, and white perch.

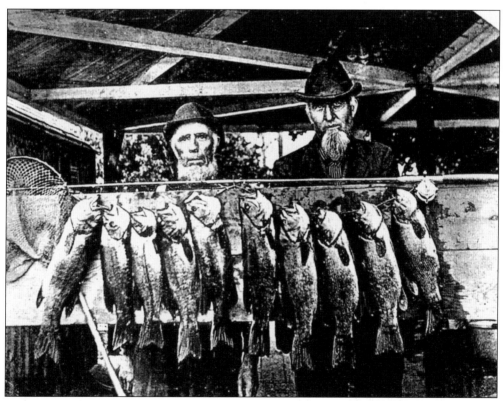

In the past, Lake Sebasticook had the reputation of being the best white perch fishery in Maine, perhaps the best anywhere. Not only were perch taken in great numbers, but their consistent large size was unsurpassed.

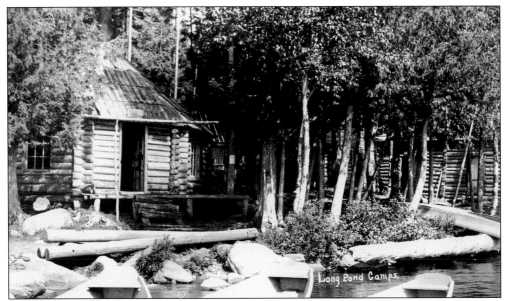

Long Pond Camps consisted of 10 log cabins set at the end of a lake abounding with trout and salmon. For the hunter, an abundance of moose and deer were found in the area. The cabins were located west of Katahdin Iron Works on Long Pond.

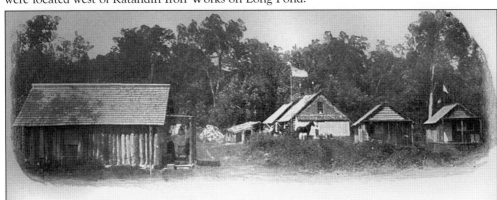

Also located in the Katahdin Iron Works area were the Pleasant River Camps, operated by G. I. Brown and his son. The Pleasant River was very famous for yielding large catches of sizeable brook trout. (*In the Maine Woods*, 1902.)

Three
GRAND LAKE STREAM

Washington County and the Grand Lake Stream Region have long been famous as a sportsman's paradise. Trout, salmon, bass, white perch, and pickerel are all readily available, and the region has long been known for its deer hunting. Grand Lake Stream, shown here, is very famous as landlocked salmon water.

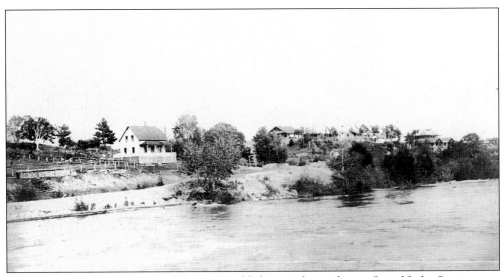

Balls Camps is one of the several famous establishments located near Grand Lake Stream.

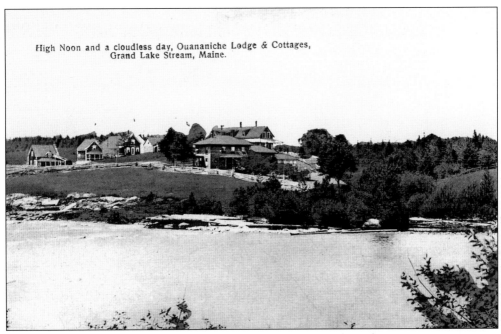

High Noon and a cloudless day, Ouananiche Lodge & Cottages,
Grand Lake Stream, Maine.

Ouananiche (salmon) Lodge and Cottages were located not far from the river.

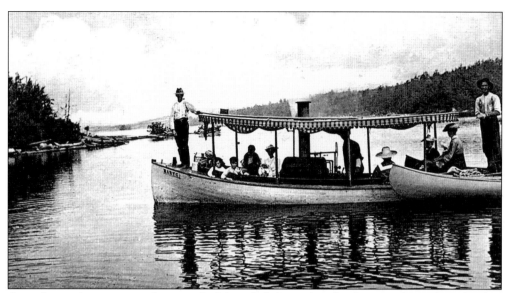

One of several steamers in the area, the *Mary C.* belonged to the Ouananiche Lodge. The ship was used for ferrying guests to and from the camps, as well as taking anglers to other areas for a day's fishing.

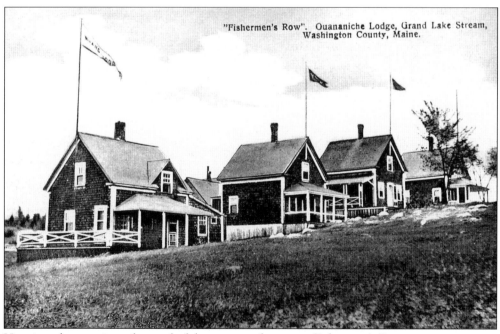

Here is a closeup view of several of the cottages, known as Fisherman's Row.

The Best Managed Camps in Maine. *One of our separate Cabins*

Bay View Camps

LOWER DOBSIS LAKE

Located on one of the St. Croix Chain of Lakes, famous for their salmon fishing, also good fishing for Trout, White Perch and Pickerel. Good hunting country for Moose, Deer and Bear. An ideal spot to spend your summer vacation. Splendid canoe trips. Fresh vegetables, plenty of milk and cream and fresh eggs. Home cooking, Long distance telephone, daily mail, Auto road to Bottle Lake. No tuberculosis guests taken. Rates $2.00 a day, $10.50 and $12.00 a week. Good winter fishing for salmon. Camps open Feb. 1, to Dec. 15. On the Maine Central Railroad from Bangor to Winn station. **JOE PATTEN, Proprietor** P.O. Address, **Springfield, Me.**

References and descriptive booklet sent on request.

Northwest of Grand Lake Stream is an area known as the St. Croix chain of lakes, and one body of water is known as Lake Sysladobsis. The Bay View Camps were one of several facilities located in this area. (*In the Maine Woods*, 1911.)

The Norway Pines House and Camps is another establishment in this immediate area. This region is very sandy, giving rise to Norway Pines in many areas, which has resulted in some very picturesque locations. Fishing and hunting in this region have been excellent for many years.

Four
THE SEBEC LAKE AREA

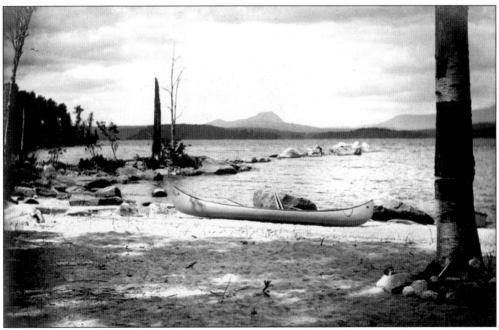

Sebec Lake is one of the original Maine lakes with landlocked salmon. A relatively small body of water, it has had a few resorts on it for quite some time.

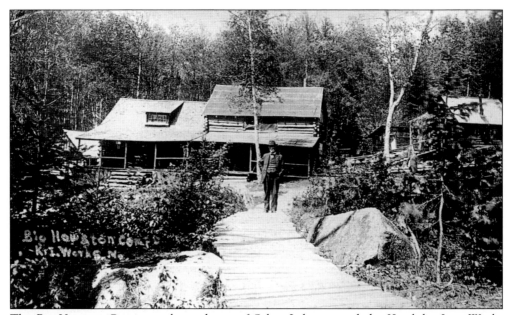

The Big Houston Camps are located east of Sebec Lake, toward the Katahdin Iron Works Region. Located on a small body of water, the area is rich in game and fish.

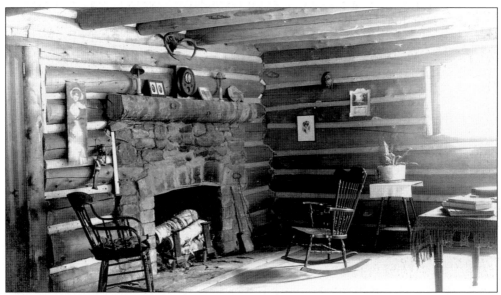

This view shows the fireplace and sitting room in one of the camps.

Chairback and Columbus Mountains from our Camps

This photograph shows the wonderful view of water and mountains seen from the camps. (*In the Maine Woods*, 1911.)

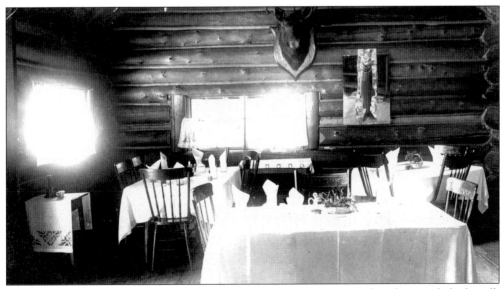

This lodge set a fancy table, with fresh vegetables from their own garden along with fresh milk and eggs.

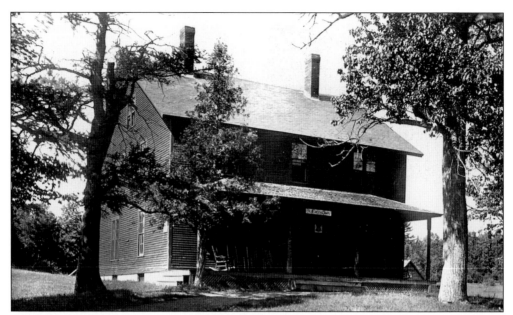

Located near Sebec Lake at the point where Wilson Stream enters the area, Earley's Camps are an institution in this area. Shown here is the main lodge, which Bill Earley purchased in 1903, operating it as a hotel. Eventually the operation was expanded to include housekeeping cabins, and the facility thrived for more than 50 years.

Here is a view at Earley's Falls looking downstream toward Sebec Lake. This is a very famous spot for landlocked salmon fishing.

Bill Earley's Sebec Lake Camps
for the Ideal Vacation

OUR camps are on the finest location on beautiful Sebec Lake, famous for its exceptional Spring Fishing. Bass and salmon fishing, fly or bait, in May and June. Special rates for June and September. Good auto road to camps.

Individual cabins with open fires and running water. Our excellent table is supplied from our own farm.

Tennis
Croquet
Bathing
Boating

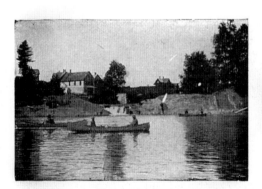

Sebec's Famous
Salmon Pool
Right at Our
Front Door

W. L. EARLEY

GUILFORD R. F. D. 3 MAINE

This is one of Earley's more extensive advertisements describing his location. (*In the Maine Woods*, 1924.)

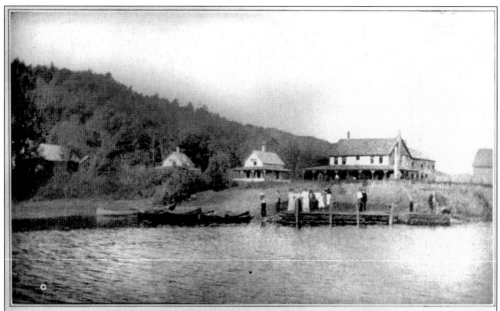

LAKE HOTEL AND CAMPS

Here throughout the season the Landlocked Salmon and Black Bass Fishing is unequalled in the State of Maine, as the house is at the head of the lake where the best fishing grounds are located. The house has modern plumbing and sanitary arrangements. Fourteen Cottages and Log Cabins in connection, ten with bath rooms, they all have open fires. You can live in a cabin and take meals at the house, an ideal place for families to spend the summer. Tennis Court for the use of guests. Post office and telephone in the house. Steaks, Chops and Fish broiled over a Charcoal Broiler.

Booklet and rates on request. **B. M. PACKARD, Prop.** Piscataquis County Sebec Lake, Me

The other famous establishment at Sebec Lake is Packard's Camps, once known as the Lake Hotel and Camps. Begun in 1894, the resort once served meals, but it now consists of housekeeping cottages. (*In the Maine Woods*, 1916.)

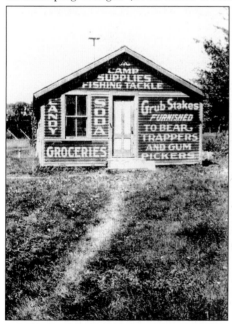

This is the trading post at Packard's, where supplies were purchased.

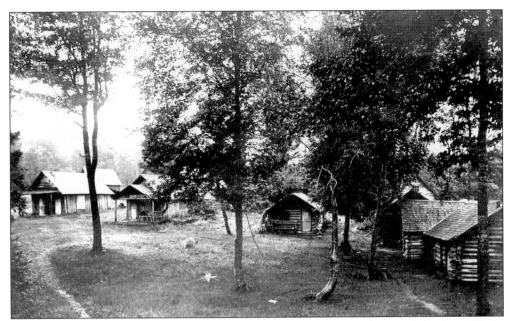

Freese's Camps is another off-the-beaten-track establishments in the Katahdin Iron Works Region just east of Sebec Lake. It was reached by a 12-mile buckboard ride. In 1907, owners advertised 10 cabins with spring beds, and trout fishing that could not be duplicated anywhere.

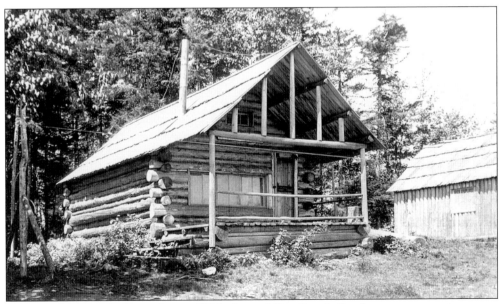

Yoke Pond Camps are located east of Kokadjo and First Roach Pond.

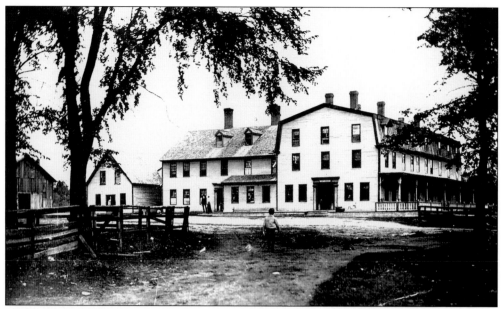

The Silver Lake Hotel was located in the village of Katahdin Iron Works, northwest of Brownville Junction. While it catered to a variety of clientele, a number of people stayed here in order to take advantage of the excellent fishing and hunting in the area.

SILVER LAKE HOTEL, KATAHDIN IRON WORKS, MAINE.

ABSOLUTELY THE HEALTHIEST SPOT IN MAINE.

SITUATED in the heart of the big game region, near the very best Trout fishing and good camps. The famous

MINERAL SPRING

is close by the hotel. Invalids and people seeking rest invariably find the mountain and iron air most beneficial, while hay fever is unknown here.

House has recently been put in good repair. All rooms with a good view. Bath rooms have hot and cold water. First-class table. For moderate terms, address

Proprietor SILVER LAKE HOTEL,

KATAHDIN IRON WORKS, ME.

Due to the geology of the area, as well as the abundance of iron ore, there were mineral springs here, which the hotel capitalized on. (*In the Maine Woods*, 1906.)

Five

THE KENNEBEC RIVER VALLEY

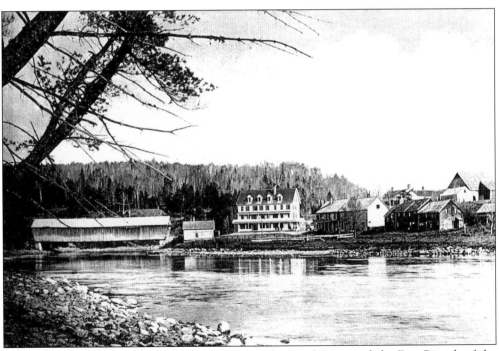

The Forks is a village situated at the junction of the Dead River and the East Branch of the Kennebec River. Because of the fishing, hunting, and logging in this region, several hotels and resorts were established over the years. Shown here is the Forks Hotel, built *c.* 1876. It contained 100 rooms and burned in 1906. It was later replaced by a smaller structure.

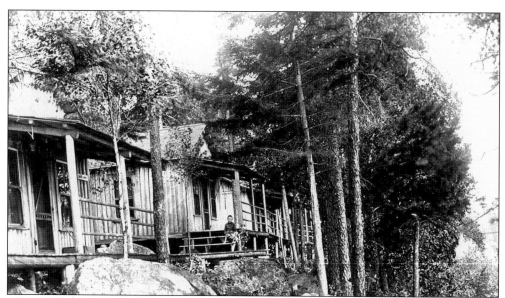

Located on 22-acre Birch Island in Attean Lake, Attean Camps consist of a lodge and a number of cabins made of peeled spruce logs. These camps have been in the Holden family since c. 1900.

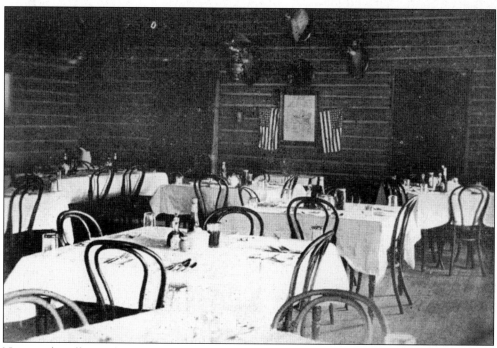

Next to the office is the dining camp, the interior of which is shown here.

The waterfront of the camps is shown in this view. Attean Lake is about five miles long and three miles wide. It contains 42 islands.

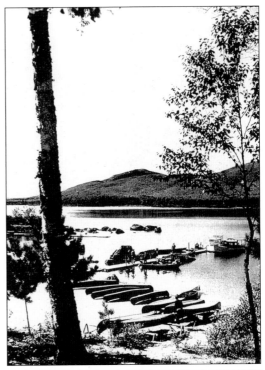

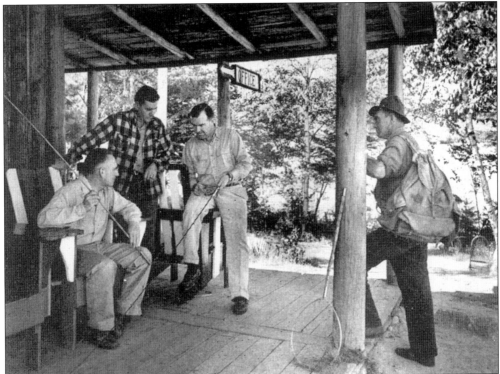

On the porch of the office, anglers compare notes and inspect fly rods. Attean Lake has long been known as an excellent trout and salmon water.

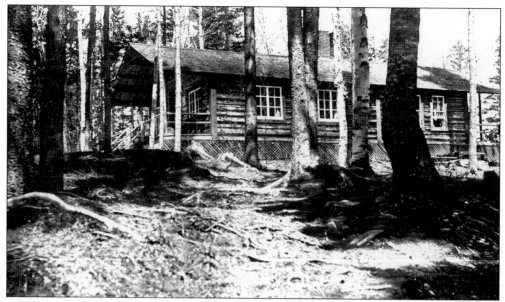

Crocker Pond Camps were located on Crocker Pond northwest of Jackman, just 12 miles south of the Canadian border. While Crocker Pond itself has been known as good trout water, a number of outlying ponds produce consistent trout fishing.

CROCKER LAKE CAMPS

JACKMAN, ME.

The ideal spot up in the north woods of Maine, beautifully located among the Pines and Birches of Somerset County; twelve miles south of the Canadian Border, five miles north of Jackman Village, only one-half mile from automobile road, with an elevation of 1631 feet above sea level. Fine cabins, electric lights, wide piazzas, running spring water, with and without baths. Fine salmon and rainbow trout fishing. Twelve outlying ponds within a radius of three miles that are well stocked with trout and take the fly readily the whole season. Miles of River and Stream fishing. Picturesque canoe trips; wonderful deer, bear, bob-cat, and partridge hunting in season. Excellent food, American plan. Telephone and telegraph connections. For further particulars write J. B. McKENNEY, Prop., Jackman, Maine.

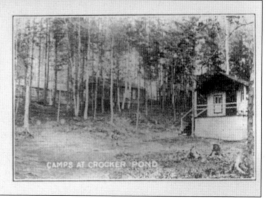

This establishment is one of the more remote in the region. (*In the Maine Woods*, 1925.)

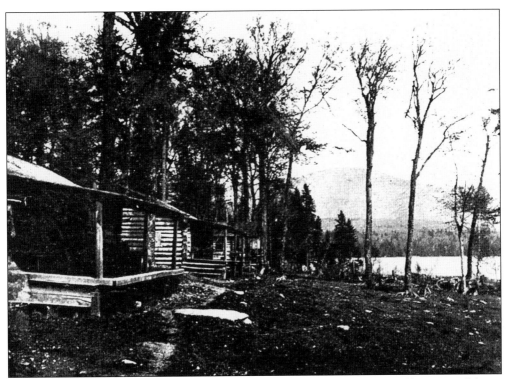

Heald Pond Camps is another of the fairly remote facilities providing excellent trout fishing. Located almost north of Jackman and east of Route 201 headed for Canada, this establishment existed off by itself and consisted of 14 well-furnished cabins, each with electricity and fireplace. This pond and other nearby waters always produced good trout fishing.

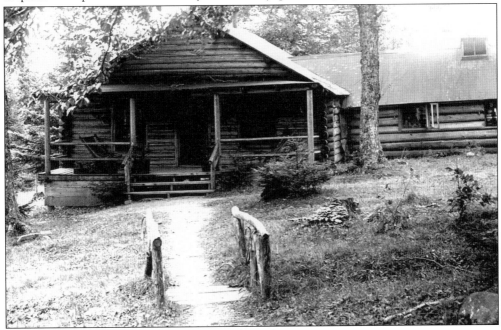

The dining camp for Heald Pond Camps is shown here.

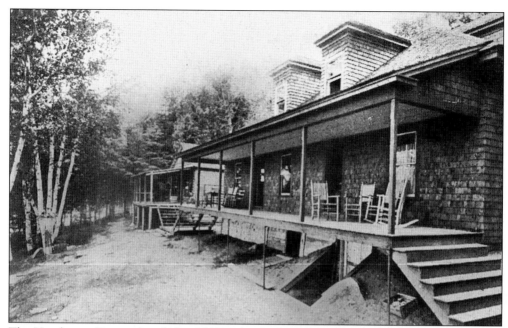

The Henderson Camps, founded c. 1907 and once known as Wood Pond Camps, are situated on Big Wood Lake in Jackman. Pictured here is the dining camp.

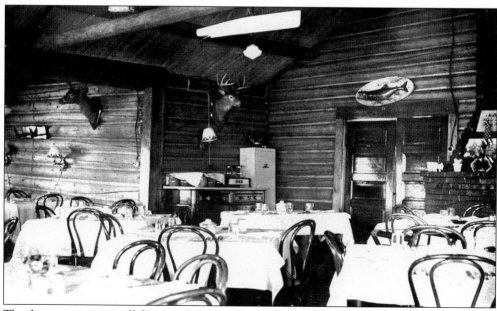

The dining room was well decorated with trophy game and fish, and it looked out over the lake.

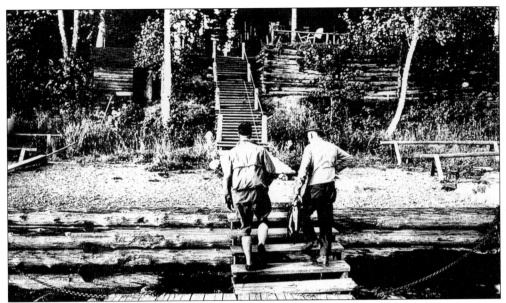

Here, two successful anglers return to camp showing results of their efforts. Big Wood Lake has long enjoyed a reputation for excellent trout and salmon fishing.

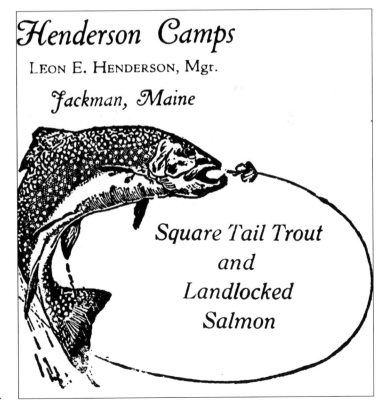

Henderson Camps

LEON E. HENDERSON, Mgr.

Jackman, Maine

*Square Tail Trout
and
Landlocked
Salmon*

This is a copy of a mailing envelope from the Henderson Camps.

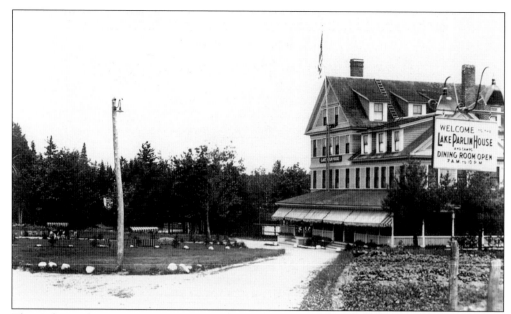

The Lake Parlin House was a very famous stopping place along the Canada Road from Skowhegan to Jackman (now known as Route 201). Since the fishing was so good in this area, this establishment grew with the addition of log cabins along the shore of Lake Parlin. The hotel burned in the 1950s, but a lodge of different proportions still exists here.

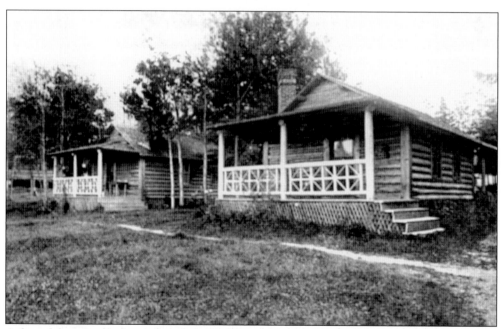

A few of the several camps along Lake Parlin are shown here. In addition to these camps, the establishment had several outlying camps on nearby ponds where trout fishing was excellent.

Lake Parlin Hotel and Lodges

Jackman Station, Maine

❖ MENU ❖

August 6 1929

Evening Meal

English Beef Broth, creole

Sweet Gherkins Iced Cucumbers

Sliced Cold Ham **with Potato Salad**

Honeycomb Tripe Lyonnaise

Omelet with Liver Saute

Boiled Lang Pond Trout, lemon butter
Compliments of Mr. John DeGraw

To Order
Broiled Sirloin Steak Lamb Chops
Panned Pork Chop, green apple sauce
Broiled Sugar Cured Ham

Cold Cuts
Boiled Ham Roast Beef
 Roast Pork Smoked Ox Tongue

Baked Potatoes Country Fried Potatoes

Garden Lettuce, French dressing

Hot Raised Rolls

Dessert
Apple Pie Squash Pie
 Chocolate Cake Snow Cake
HawaiianPineapple Chocolate Ice Cream
 Cream Cheese, saltines
 Toasterettes
Tea Coffee Milk

Canada Dry Gingerale 20¢ White Rock

MEAL HOURS: 7 to 9 a. m. 12 to 2 p. m. 6 to 8 p. m.
Sunday 7.30 to 9.30 a. m. 12.30 to 2.30 p. m. 6 to 8 p. m.
Meals cannot be checked out — A la Carte charges made for all service after regular meal hours

Typical of facilities of this nature, an extensive menu of fine food was the regular fare.

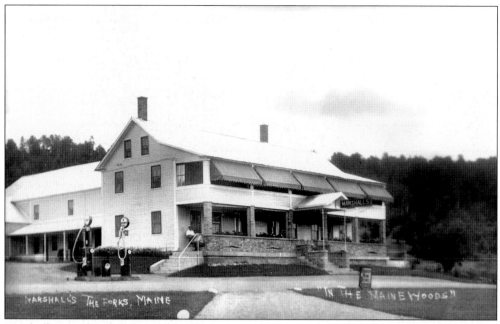

Marshall's Hotel and Cabins at the Forks consist of a main building along with several camps along the banks of the Kennebec River. This establishment is located on both sides of the highway, just south of the Forks village and the junction of the Dead River with the East Branch of the Kennebec River. For years the lodge served meals at a dining room in the main building.

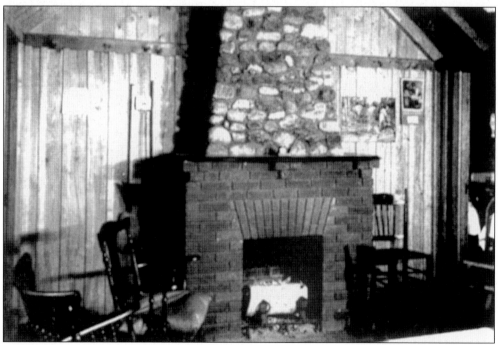

Shown here is the fireplace in a cabin containing two bedrooms and a bath.

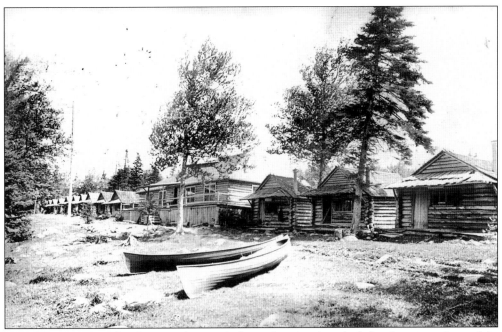

Round Mountain Lake Camps advertised themselves as the ideal family resort, located in northwestern Maine, midway between Rangeley, Moosehead, and Megantic Lakes in the wildest and most mountainous part of the state. Dion Blackwell operated the camps for over 45 years.

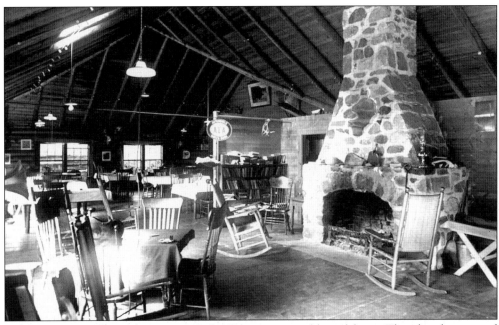

The dining area at Round Mountain Lake Camps was sizeable and fancy. Their brochure stated that every attention was given to the quality of the food rather than to great variety, and only the best is served.

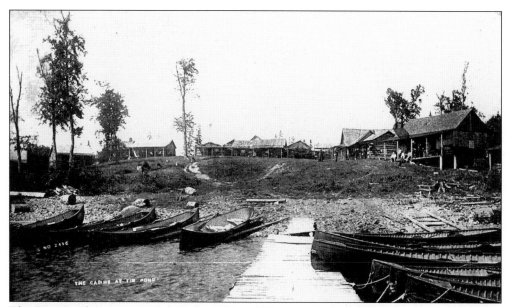

The Tim Pond Camps are not far from Round Mountain Lake, slightly to the south toward Rangeley. Begun as a sporting camp in 1877, today they are known as Tim Pond Wilderness Camps. They consist of a main lodge with a number of individual cabins.

This is a copy of letterhead from Tim Pond Camps. The design is fitting for an area that is predominantly trout water.

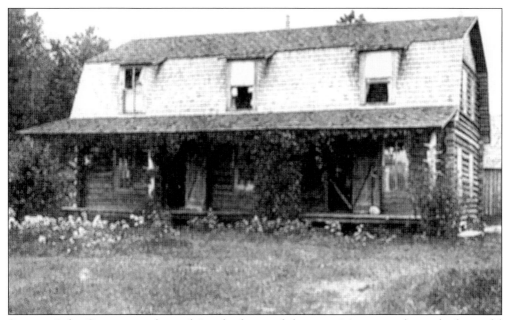

Spencer Lake Camps were located "in the heart of the great Maine woods on the beautiful shores of Spencer Lake." Located south of the Jackman area and west of Route 201, this establishment consisted of a main lodge containing a dining area, which is shown here, along with 20 log cabins. Hunting and fishing in this area was likely the best.

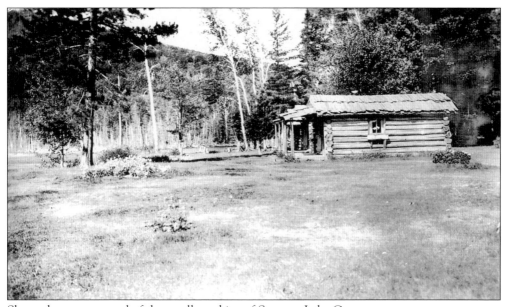

Shown here are several of the smaller cabins of Spencer Lake Camps.

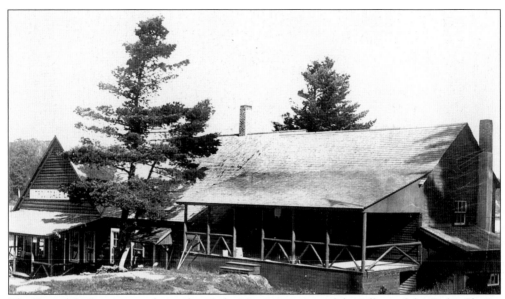

The Troutdale Camps were located on Lake Moxie, just east of the village of the Forks. Shown here is the main lodge and dining area.

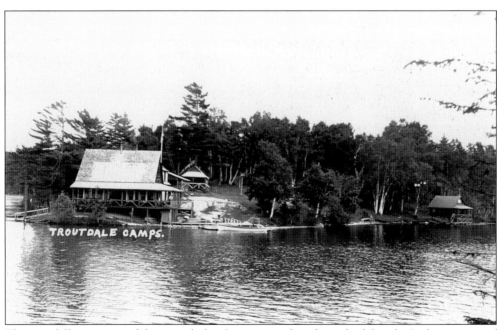

This is a different view of the same lodge, but it was taken from the lakeside. It shows some of the nearby cottages.

Here is one of the individual cabins located on the shore of the lake.

While fish and game are plentiful in this area, some of the views are spectacular, and dawn rising over Lake Moxie, or any small body of water unruffled by winds, can be breathtaking.

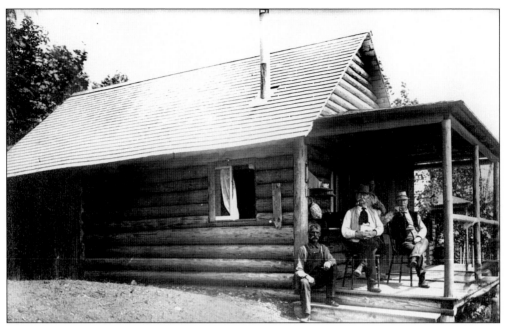

Jones Camps was another establishment located on Lake Moxie. One of their log cabins is shown here.

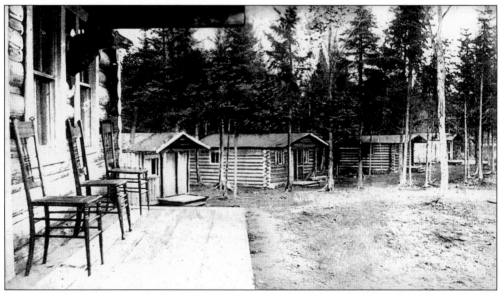

Trout Brook Camps were located in Mackamp, south of Long Pond and east of Jackman. Excellent trout fishing was found in this area.

Six

THE MOOSEHEAD LAKE REGION

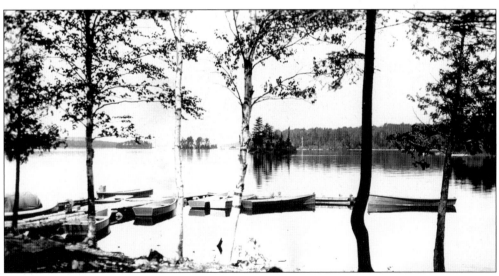

Early morning on a flat calm lake is a sight to behold, but few have the opportunity to witness it. Here is a shot from the Greenville area looking northerly up the lake.

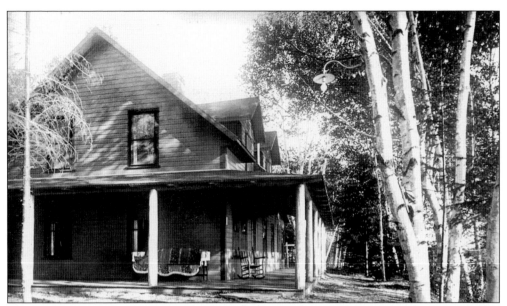

The Birches, located in Rockwood, consist of a main lodge with dining area along with 20 log cabins. While operated differently than in the past, this establishment is still in existence.

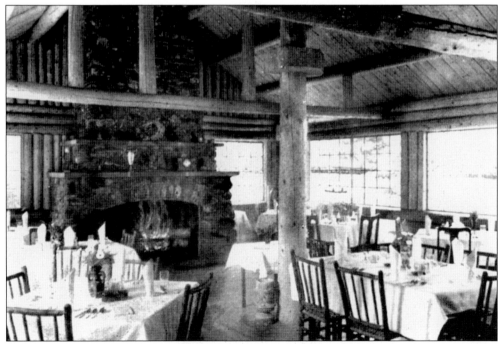

The dining area was quite extensive, and the food was outstanding. The fireplace shown here provided quite an attractive atmosphere.

The BIRCHES
on Moosehead Lake

July 17th, 1954

L U N C H E O N

Fruit Juice Blend
Grapefruit Juice
Tomato Juice
Crackers

Jellied Consomme
Beef Broth au Sherry

Chipped Beef in Cream on Toast
Maryland Crab Cakes, Baltimore
Broiled Salisbury Steak, Sauce Piquante
Western Omelette

Parsley Potatoes
Buttered Cauliflower

Garden Leaf Lettuce
Carrot Sticks Dill Pickles Garden Radish
Sectioned Tomatoes
Spiced Pearl Onions
Apricot Jam

White and Dark Home Made Bread

Maine Apple Pie
Cherry Pie
Chocolate Cake, Fudge Frosting
Maple Nut Sundae
Sugar Cookies
Raspberry Parfait
Fancy Peaches in Syrup
Chocolate Vanilla Coffee Ice Cream
Lemon Sherbet

Tea Coffee Milk Sanka Cocoa
Hot or Iced

Keep Maine Green

This menu speaks for itself, consisting of a variety of choices, including homemade desserts.

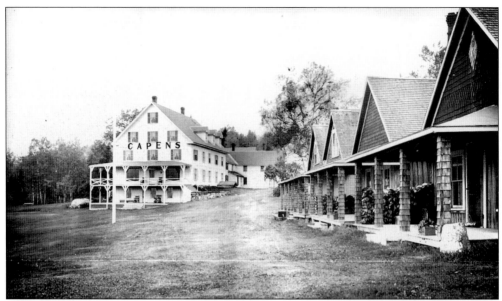

The Capens once consisted of a large hotel and several nearby cottages. It was located on Deer Island, consisting of 2,500 acres in Moosehead Lake, which was purchased from the state of Maine by Gen. Aaron Capen in 1832. For many years, the Capen family operated this establishment for fishermen and hunters until the hotel was destroyed by fire in 1953.

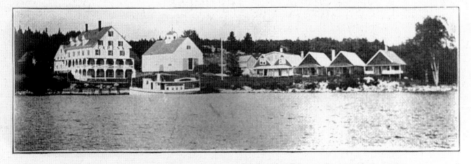

CAPEN'S—MOOSEHEAD LAKE

This is a Modern Hostelry on Maine's Most Beautiful Lake
Excellent Table—Private Camps for Parties—Fine Hunting, Fishing, Canoeing, Boating and Tennis—Daily mail and long distance telephone.
Rates $2.50 to $3.50 per day, $14 to $21 per week. Write for our booklet

CAPEN'S, MOOSEHEAD LAKE, MAINE

Shown in this advertisement is the Capens steamboat, the *Tethys*, which was used to ferry parties to and from Greenville to the south. Capens advertised the best of home cooking with food from their own farm, including eggs, cream, butter, and vegetables. Rooms and cottages had open fires and electric lights. (*In the Maine Woods*, 1918.)

Camp Caribou was located at the north end of Moosehead Lake at a location known as Ogontz. Reachable only by boat, Caribou consisted of a main camp and dining room along with several individual cabins. It was advertised as "the camp nearest the famous Norcross Point and Duck Cove fishing grounds."

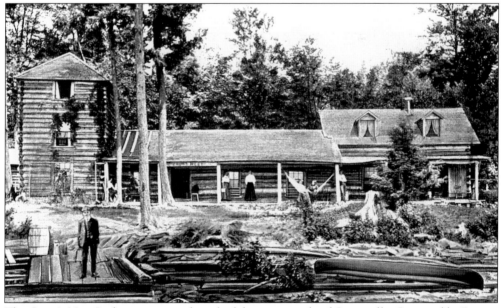

The Crow's Nest Lodge was situated on the lake just outside of Greenville. Operated by Bigney and Rowe in the early 1900s, there were separate camps for small parties. They operated their own steamer, known as the *Sprite*.

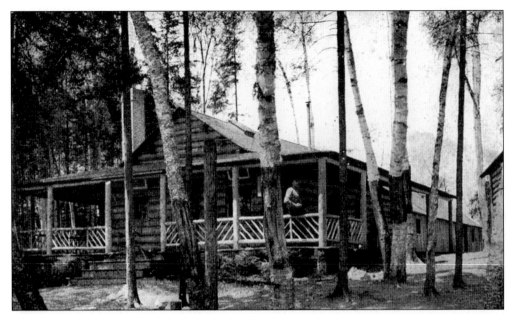

Camp Greenleaf was located on Sugar Island. It consisted of a main lodge and seven individual cabins built of spruce logs with open fireplaces. Their advertisement stated that they were located "undoubtedly nearest to the best fishing grounds in Maine."

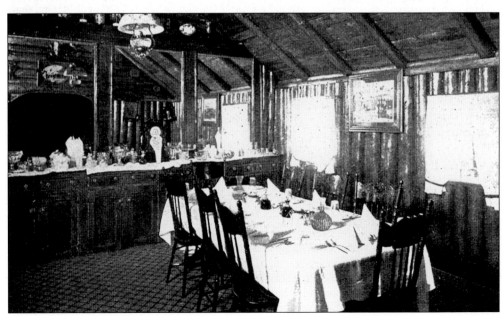

The dining area at Greenleaf was impressive indeed. They stated that their cuisine was unsurpassed.

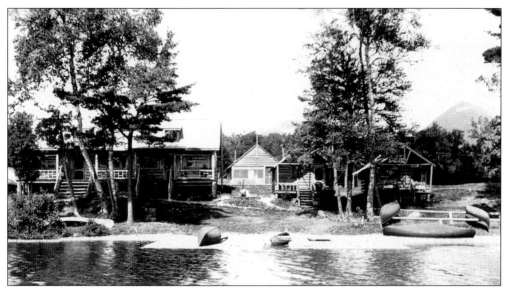

Kidney Pond Camps, a group of small log cabins located nearly adjacent to Mount Katahdin, all face the lake. They advertised exceptionally good food, including an abundance of fresh vegetables and produce from their own farm.

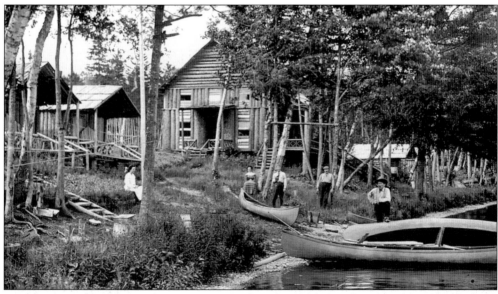

In addition to the camps at the main site of Kidney Pond Camps, there are also outlying camps and about 20 small ponds in the area where trout up to three pounds were said to be in abundance. Salmon up to 12 pounds were also in abundance in the West Branch of the Penobscot River. The camp also advertised that the adjacent woods were unsurpassed for game during the hunting season.

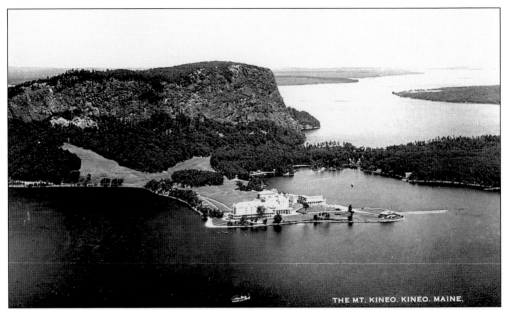

Probably the most extensive and luxurious establishment in Maine, the Mount Kineo Hotel sat at the base of Mount Kineo in the middle of Moosehead Lake. Reachable only by boat from Rockwood, Kineo relied heavily on Maine Central Railroad Service to Rockwood from points south. Its advertisement located it "in the Centre of the Great Wilderness on a Peninsula under the Shadow of Mount Kineo." In 1906, the resort called itself the "largest inland-water hotel in America."

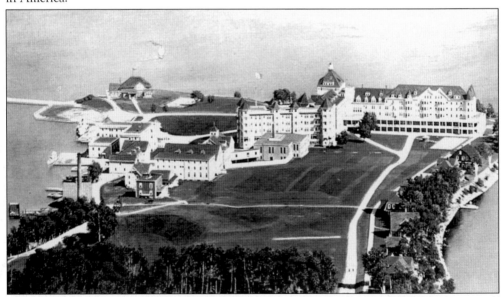

The Mount Kineo was a village unto itself, with extensive buildings, several cottages, a golf course, and tennis courts. At one time, it boasted a staff of over 400 people. Plagued by several fires, the hotel was rebuilt several times over the years. The plan for the resort began in 1844, and the first hotel was built in 1848. By 1884, the resort had 200 rooms accommodating 500 guests. A major fire in 1938 destroyed the hotel, which was rebuilt as a smaller structure accommodating 120 people. The final demolition of the truly grand hotel took place in 1995.

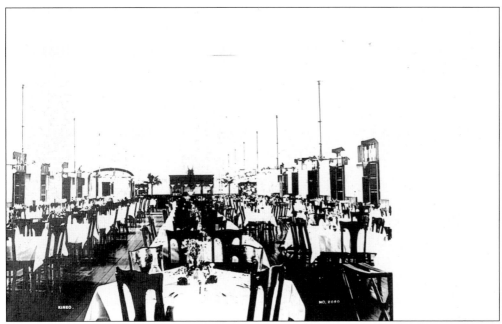

By 1900, the dining area shown here could seat 400 people, and by 1911, it could seat 500. Up the shore of the lake, the Mount Kineo also maintained Deer Head Farm strictly for a supply of produce for its patrons.

Sunday, Sept. 9th, 1894.
— DINNER —

Consomme, Vermicelli Puree of Tomatoes, au Crouton
 Lettuce Celery Olives

Boiled Penobscot Salmon with **Green Peas**
 Sliced Tomatoes Cucumbers

Boiled Turkey, Oyster Sauce

Chicken Croquettes, **Sauce Supreme** Fillet of Beef, Mushrooms
German Toast, Vanilla Cream

ROMAN PUNCH

Ribs of Beef—Dish Gravy **Domestic Duck**—Apple Sauce
Spring Lamb—Mint Sauce

Boiled Potatoes **Mashed Potatoes Pickled Beets** Green Corn
Mashed Turnip **Boiled Rice** Green Peas
Fried Egg Plant

English Plum Pudding, Hard and Brandy Sauce
Baked Custard Pudding

 Peach Pie Apple Pie Lemon Meringue Pie

Harlequin Jelly Creme en Mousse au Kirsch Vanilla Ice Cream
English Walnut Cake French Maccaroons Lady Fingers
Toadstools a la Richelieu Assorted Cake

 Apples Peaches Pears Grapes
Assorted Nuts Raisins

Crackers American, Pineapple and Edam Cheese

TEA COFFEE MILK

This menu provides a glimpse into the clientele being served here.

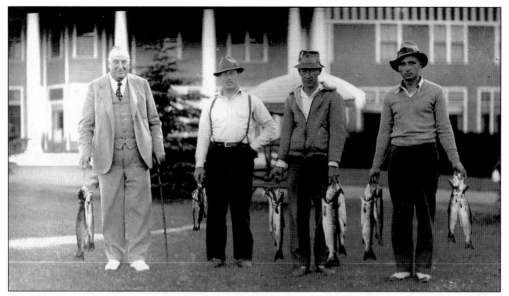

In 1914, the establishment had 62 registered guides on its payroll. Fishing was a most popular sport enjoyed by men and women alike. Here, the manager of the hotel and three of the guides display a typical catch of fish.

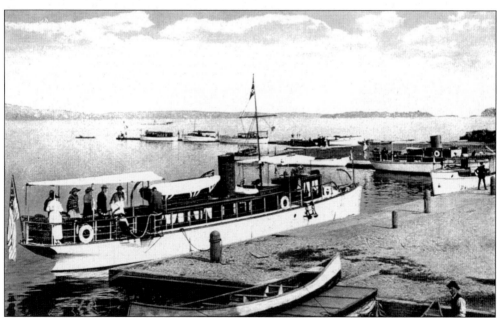

This view shows the extensive docking arrangement at the Mount Kineo, home of the Moosehead Lake Yacht Club, which was based at the hotel.

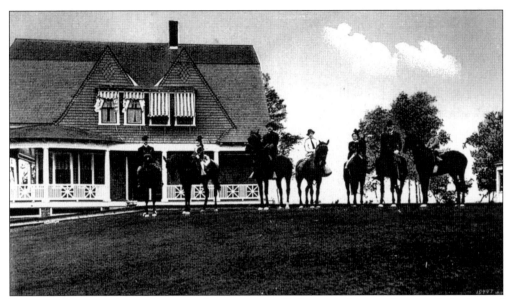

Riding stables were located here, and parties assembled to travel not only around the base of the mountain, but also on a special bridle trail that was constructed to allow passage from the hotel to the top of the mountain on horseback.

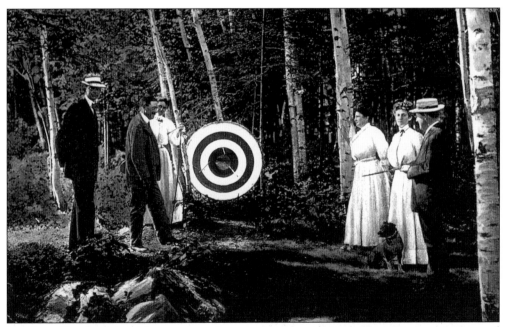

Besides golf and tennis, archery was another popular sport at Mount Kineo. Dances, parties, and special gatherings were all part of the regular offerings at the resort. Kineo indeed offered everything from the very basics for sportsmen to the most exquisite activities satisfying patrons of high society from the big cities to the south.

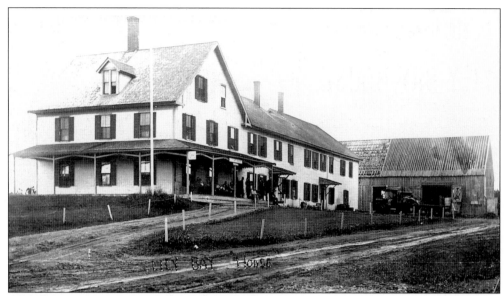

The Lily Bay House was a famous resort situated on the east side of Moosehead Lake, north of Greenville and south of Kokadjo. The resort began shortly after 1876 and thrived until it was demolished in the 1950s. Connections with Greenville were made every day during the summer by boat and by stage during the winter.

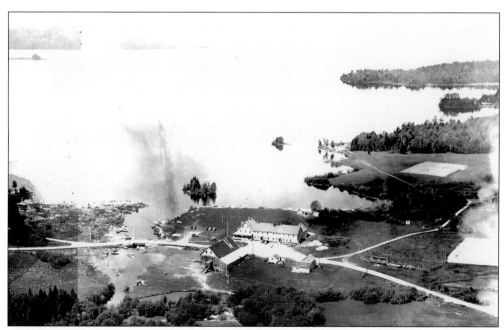

This aerial view shows the Lily Bay House and the outlying buildings. It also demonstrates the location of the establishment, showing its vicinity to prime fishing locations. The advertisement stated that in the dining room, a strictly first-class table was always set with choice and seasonable foods in ample variety. Vegetables and fresh milk were provided from the resort's own farm.

This artistic advertisement is typical of the period, and it describes in simple fashion exactly what the resort is about. (*In the Maine Woods*, 1905.)

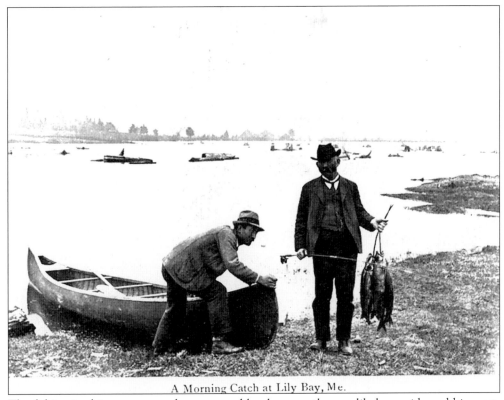

A Morning Catch at Lily Bay, Me.

The fishing in this area was as demonstrated by these gentlemen, likely a guide and his sport, seen here with their morning catch.

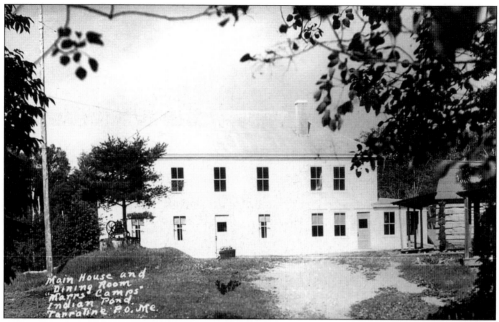

The Marrs Camps were located at the head of Indian Pond near the junction of the East and West Branches of the Kennebec River, both flowing out of Moosehead Lake. Established by Mike Marr, the operation was run successfully for many years until the 1950s, when the building of a new dam at the outlet of the pond raised the water level significantly and flooded the site.

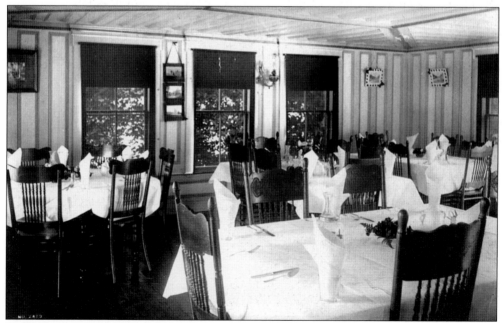

Shown here is the dining room of the Marrs Camps. Milk, eggs, and vegetables were produced at the farm located on the premises.

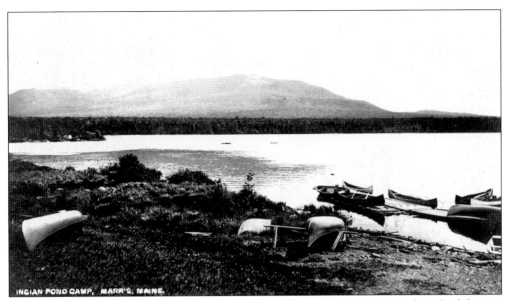

In this view looking across Indian Pond to the east, Squaw Mountain provides a backdrop to the Marrs Camps. This is the waterfront, well stocked with canoes for fishing. Marrs also catered to hunters, and for many years, the only access to this location was the Somerset Branch of the Maine Central Railroad running from Skowhegan to Rockwood.

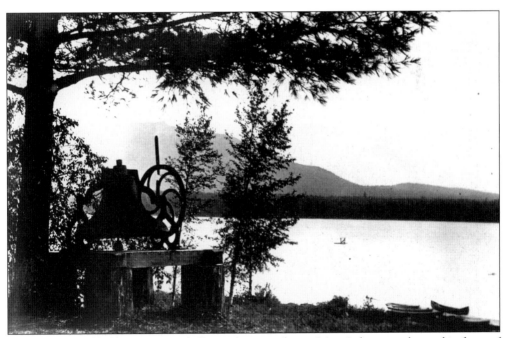

While most establishments rang a bell signifying mealtime, Marrs' alarm was located in front of the camps near the shore, where it could be heard from quite a distance.

71

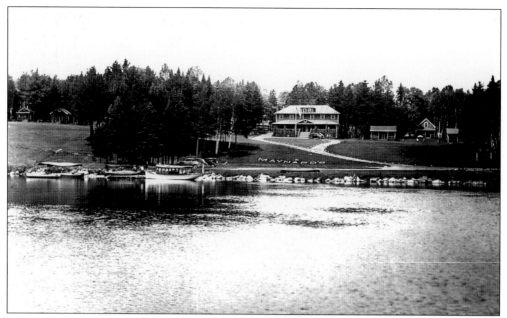

Maynard's-in-Maine was founded *c.* 1919 by Walter Maynard, and it has been in the family ever since. Seen from across Moose River are the main lodge, several nearby individual cottages, and the waterfront.

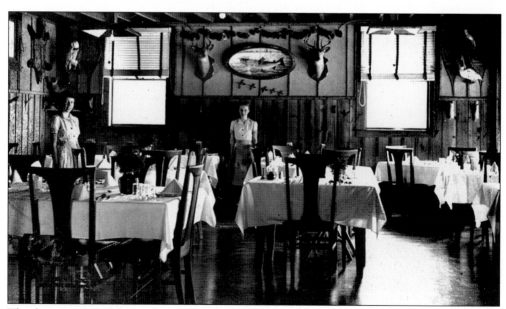

The dining room at Maynard's was furnished in fancy style, and the room was well adorned with trophy game and fish.

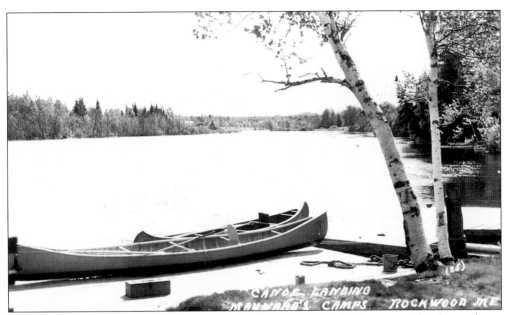

For many years, guides used canoes for fishing Moose River. Today, most people use boats equipped with outboard motors.

When Maynard's began, the establishment was known as the Firs. Even at the beginning, the resort catered to both fishermen and hunters. (*In the Maine Woods*, 1922.)

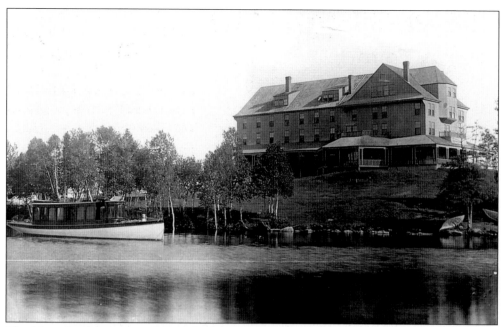

The Moosehead Inn, one of several of that name over the years, was located at Greenville Junction and very close to the lake. It was strategically located near the junction of the Canadian Pacific and Bangor and Aroostook Railroads. Because of this, thousands of sportsmen and tourists made this inn their stopping place en route to and from all parts of Moosehead Lake and the surrounding region.

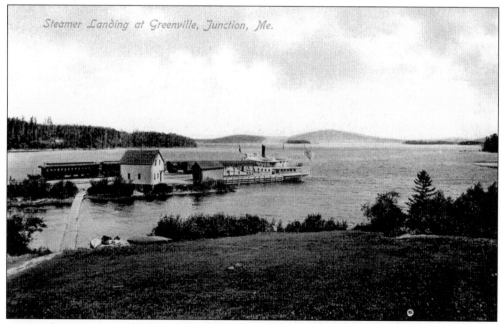

Steamer Landing at Greenville, Junction, Me.

Across the cove from the Moosehead Inn was the terminus of the Bangor and Aroostook Railroad, as well as the steamer landing. A magnificent view northward up the lake enhanced this location.

74

THE PENOBSCOT HOTEL,

NORTHEAST CARRY,
MOOSEHEAD LAKE, ME.

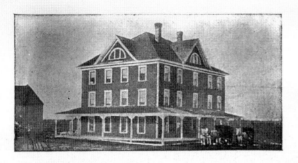

This Hotel was destroyed by fire January 29, 1902, but will be rebuilt and enlarged. Will have all modern improvements. Will accommodate 100 guests. Suite of rooms arranged for Sportsmen and their families. Ready for guests about August 1.

It will be well furnished, and provided with every comfort and convenience for travelers, sportsmen, and all persons seeking rest and recreation.

This hotel stands at the gateway of the vast hunting and fishing region drained by the Penobscot, St. John, and Allagash Rivers.

Boats running from Greenville in connection with the B. & A. R. R. trains land passengers at Northeast Carry direct. (The Penobscot Hotel is a short two miles across the Carry from the landing.) Communication with all points by telephone and telegraph. Post-office in house. Full line of sportsmen's supplies of all kinds and best grades. Reliable guides furnished. Rates reasonable. Table and accommodations first class.

THE PENOBSCOT HOTEL & TRADING COMPANY,

FRANK L. GIPSON, Manager. **(P. O.) NORTHEAST CARRY, ME.**

The Penobscot Hotel, located at the head of Moosehead Lake at Northeast Carry, served practically the same purpose as the Moosehead Inn at the beginning of the 20th century. Strategically located, it served as a stopover for parties traveling the West Branch of the Penobscot River. While this advertisement promised reconstruction, no information has been seen that it was rebuilt. In fact, Frank L. Gipson, the manager, is known to have operated the Lily Bay House at the other end of the lake as early as 1905.

Before the hotel was destroyed by fire, it was very popular with fishermen and hunters. This photograph shows at least 17 deer hanging from the porch.

Known by a variety of names, including Kokad-jo Inn and Roach River House, this establishment is located by the outlet of First Roach Pond where the famous Roach River begins its journey to Moosehead Lake. It was established *c.* 1880.

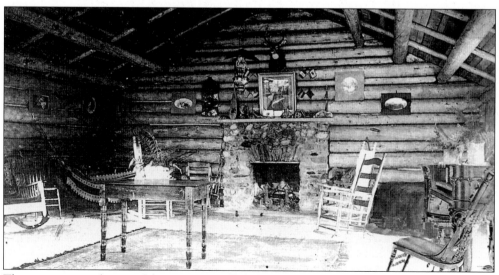

This is a view inside one of the cottages, called the Sportsman's Paradise.

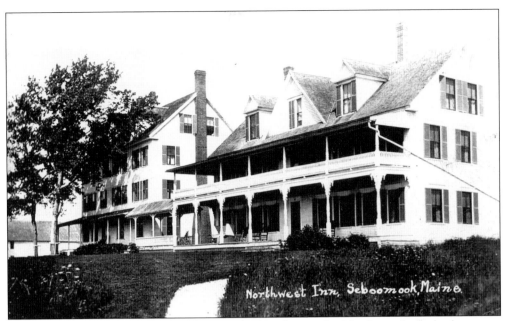

At the north end of Moosehead Lake, at Seboomook, was the Northwest Inn, also known as the Seboomook House. It advertised the very best of fishing and hunting.

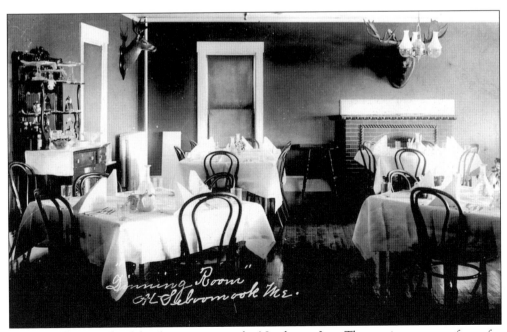

This is a photograph of the dining room at the Northwest Inn. The service was very fancy for such a remote location, nearly 40 miles from Greenville at the other end of the lake.

Once known as the Spencer Bay Club, as well as a variety of other names including Treadwell's, Gilbert and Stevens, Houghton's, and others, Spencer Bay Camps consisted of a main lodge with several nearby individual cottages. This establishment still exists today at this site.

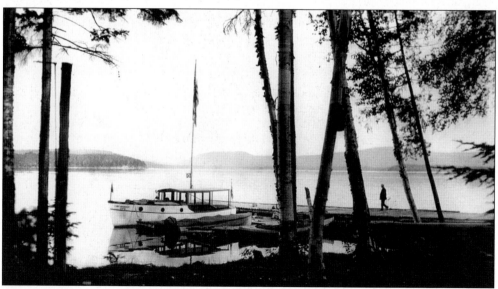

This view shows the waterfront and most of Spencer Bay at the northeast end of Moosehead Lake. This resort is the only one in the bay, and it is located at its mouth, where the broad expanse of the main lake opens up to the southwest.

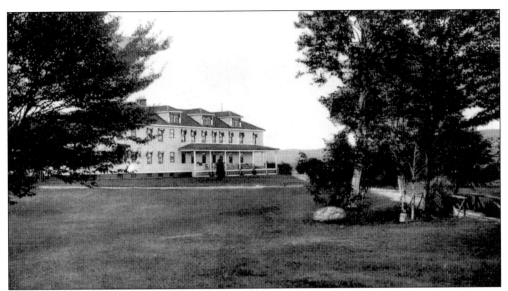

The Squaw Mountain Inn began as a sanatorium and was operated from 1901 to 1909 for that purpose. It was closed after the resignation of the doctor in charge, and it became a summer resort, opening for the first time on May 15, 1915. The hotel was enlarged, a golf course built, and a number of fancy amenities installed. Becoming one of the fancier establishments of the area, it was visited by a number of dignitaries, including President Truman, Secretary of State Christian Herter, and singer Rudy Vallee. In 1968, a fire in which five people lost their lives leveled the resort.

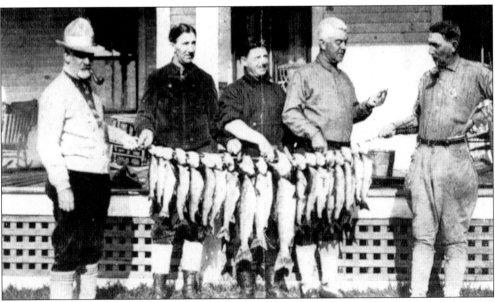

Besides catering to wealthy clientele, and billing itself as a "high-class family inn," Squaw Mountain Inn also hosted many sportsmen, primarily fishermen. Here, a group displays their catch from nearby Moosehead Lake.

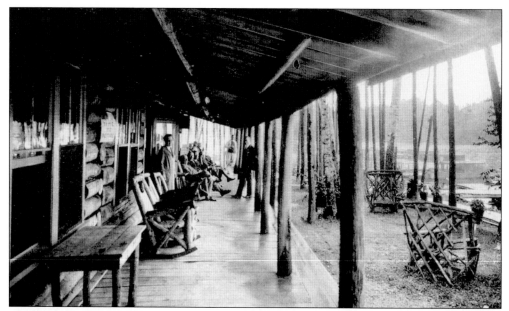

The West Outlet Camps was a sizeable establishment consisting of a main lodge with an office and dining area shown here, along with 20 individual cottages and outbuildings. It was located at the West Outlet of the Kennebec River where it flows out of Moosehead Lake.

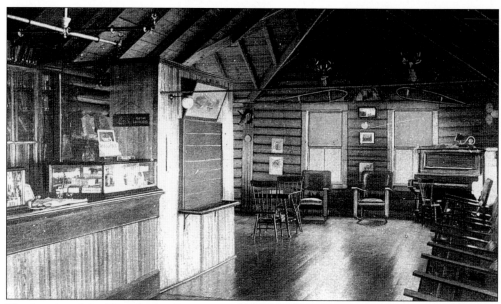

The interior of the West Outlet Camps main lodge building, namely the office and lounge area, is shown here.

WEST OUTLET CAMPS,
WEST OUTLET, ME.

Canape of Sardines

Cold Bouillon en Tasse

Clear Green Turtle a l'Anglaise Puree of Tomatoes au Riz

ICED CUCUMBERS QUEEN OLIVES LETTUCE

CUCUMBER PICKLES

Baked Lake Trout a la Yahn

Boiled Leg of Southdown Mutton, Caper Sauce

PICKLED BEETS

Roast Sirloin of Beef, Dish Gravy

Philadelphia Capon, Giblet Sauce

Spring Lamb, Mint or Brown Sauce

Sweetbread Croquettes with Peas Stuffed Cucumber a l'American

Apple Fritters, Glace au Rhum

Kippered Herring Philip Canard Sardines

Chicken Salad Mayonnaise

Mashed Potatoes New Boiled Potatoes

Hubbard Squash Mashed Young Turnip Fresh Green Peas

Graham, Oatmeal, Pilot and Plain White Bread

Cottage Pudding, Strawberry Sauce

Apple Pie Raopberry Pie Blueberry Pie

Sponge Cake Assorted Cake

Cocoanut Ice Cream

Cantaloupe Oranges

Boston, Soda and Bent's Water Crackers

Edam and American Cheese

Ginger Ale Birch Beer Sarsaparilla

Coffee

SUNDAY, AUGUST 6, 1911.

With produce from its own supply, this establishment joins a long list of resorts offering extensive gourmet meals. Meals at many sporting lodges were not unlike those found back home in the big cities.

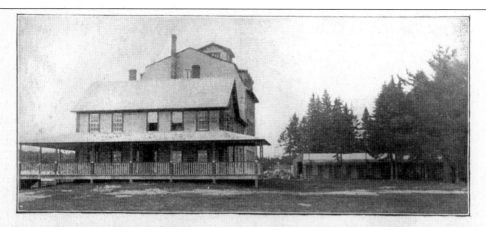

BEST FISHING

❧ AND ❧

FINE HUNTING

ᴬᵀ OUTLET HOUSE

(Formerly Moosehead House), MOOSEHEAD, ME.
11 miles from Greenville by C. P. R. R. or by Steamer.

Charles E. Wilson, ‑ ‑ Propr.

Earliest and latest Moosehead lake fishing is had here; also plenty of big game. House has been entirely re-furnished; rooms have hot and cold water and baths. Grounds nicely graded, tennis court, croquet grounds and many fine woods roads laid out. Fishermen can avoid expense of guide by coming here, although we furnish guides, boats and canoes when desired. Several camps in our "string," all snug and attractive. Rates $2.00 to $2.50 per day. Descriptive Booklet sent free.

Known through the years by a variety of names such as Wilson's Tavern, the Moosehead House, the Outlet House, Wilson's on Moosehead Lake, and finally Wilson's, this resort has a long history. It is stated that a lodge was established here by Henry I. Wilson after the Civil War (c. 1865), and that lodge became the hotel shown here. To the right of the hotel is a long motel-like structure, Fisherman's Lodge, which can be traced at least as far back as 1900. (*In the Maine Woods*, 1903.)

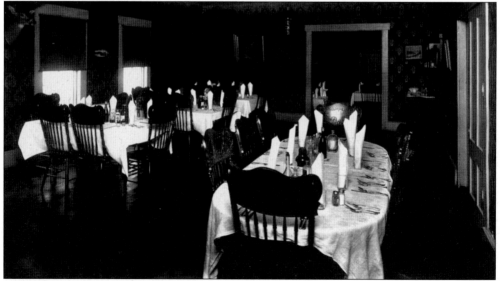

Shown here is the dining room inside the hotel. For many years, close to a century, Wilson's served meals and could seat 60 persons at any one time.

82

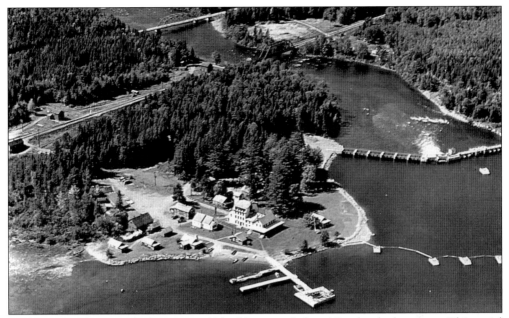

By the 1950s, the resort had grown to 40 buildings, including 17 individual cottages. This aerial view shows the proximity of the railroad station to the left, and the East Outlet of the Kennebec River to the right, a world-famous fishing location for trout and landlocked salmon. The hotel was razed in 2004, removing a landmark that was visible from a large portion of the lake.

Shown here are a few of the individual cottages made of peeled logs with large porches.

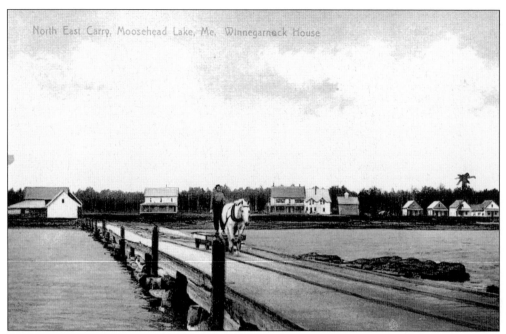

The Winnegarnock House was located at the north end of Moosehead Lake at Northeast Carry. It is shown in the background here along with several of the nearby cottages. In the foreground is a long pier with railroad tracks used for making connections with the steamboats docking here to disembark travelers going down the West Branch of the Penobscot River.

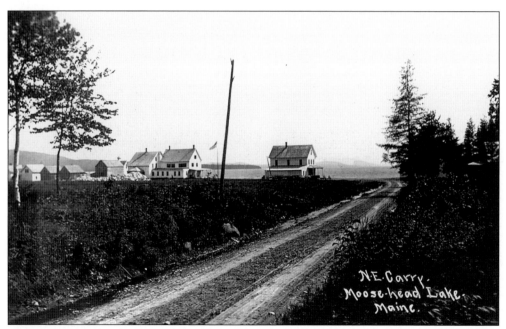

This is a view from the back of the Winnegarnock House looking south and down the lake. This site was known as the gateway to the wilderness, as well as the starting point for the West and East Branch and Allagash canoe trips.

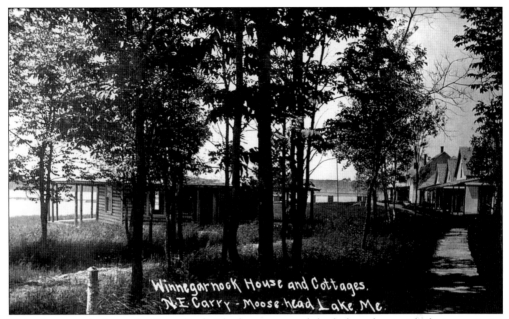

This photograph shows the line of individual cottages and the lodge, along with their proximity to the lake.

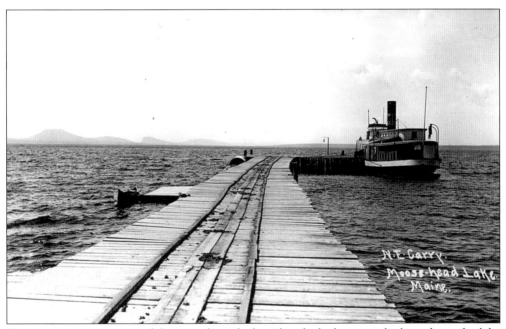

Here is an exquisite view of the steamboat dock with a docked steamer looking down the lake toward Rockwood. Proceeding from left to right, Mount Kineo is the third, or next to last, elevation. This view also shows the open expanse of Moosehead Lake. Note that the rails down the middle of the pier are made of wood.

One of the most famous trout fishing areas in Maine is Nesowadnehunk Lake, commonly known as Sourdehunk Lake. The sporting facility there is known as Camp Phoenix. In their advertising, the resort claims the best summer fly fishing in Maine for brook and lake trout.

All trout fishermen know of this location, and over the years, there probably have been more anglers and trout caught here than anywhere. The lake is small enough to be fished with a canoe, and prolific enough that everyone seems to have had good luck when fishing here.

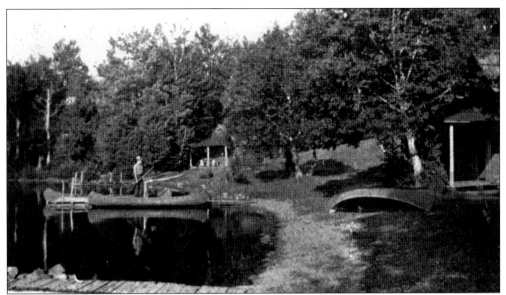

Lyford Pond Camps, later known as Sherman's Camps, are shown here situated along the waterfront of another famous trout pond. This establishment is located just east of Kokadjo.

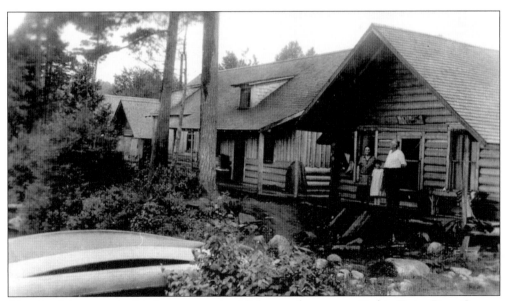

Also in this general vicinity was an establishment known as York's Twin Pine Camps. Advertised as being "right under famous Mt. Katahdin," the camps were located on Daicey Pond. Like other establishments, they produced their own vegetables and dairy supplies.

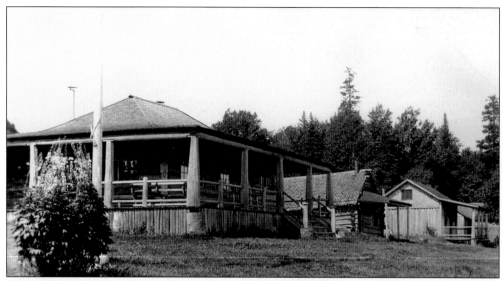

West Branch Pond Camps were founded *c.* 1890 or slightly before, and they grew to the eight log cabins that they are today. For many years, the resort has maintained a dining room in the old style, catering to guests as well as to outsiders. Shown here is the main part of the establishment.

Here is a photograph of another cabin, showing the building's proximity to West Branch Pond. This pond, along with several surrounding ponds, consistently produce large catches of native brook trout. Moose have been very abundant in this area for a long time, and the hunting is excellent.

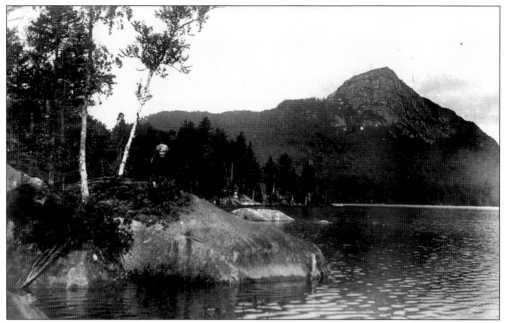

Lake Onawa, located just outside of the village of Monson and south of Greenville, had several sporting establishments on it. The lake and region are famous for Borestone Mountain, shown in this photograph. The mountain is a favorite of climbers.

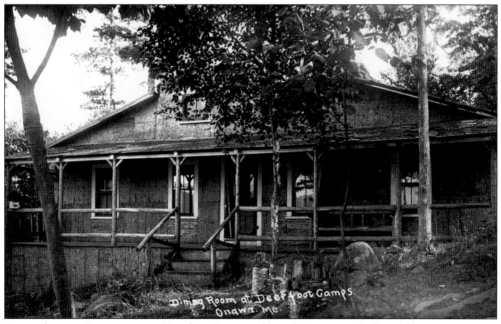

A popular sporting resort was Deerfoot Camps, whose dining room is shown here.

Another longstanding and well-known establishment was Young and Buxton's Camps, known as Camp Onawa. One of the camps is shown here on the edge of the lake. By 1927, it was under the management of C. P. Clough, and the name changed to Onawa Lake Camps.

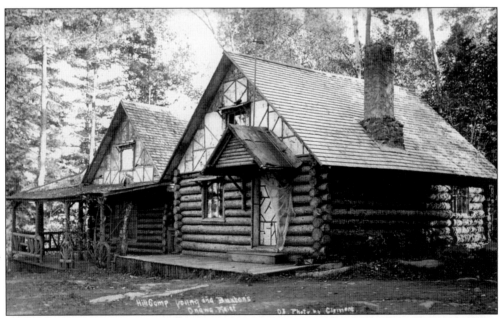

This was one of the larger cottages made available at Young and Buxton's. Onawa has long been known for good fishing for trout and landlocked salmon.

Seven

THE BELGRADE LAKES AREA

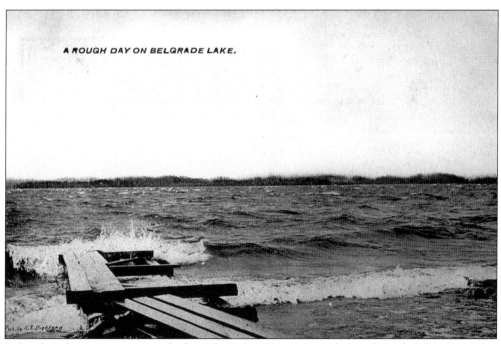

Belgrade Lake is seen on a windy day. The Lakes Region is made up of North Lake, East Lake, Great Lake, Long Lake, Salmon Lake, and Messalonskee Lake, all of which have shown excellent fishing over the years.

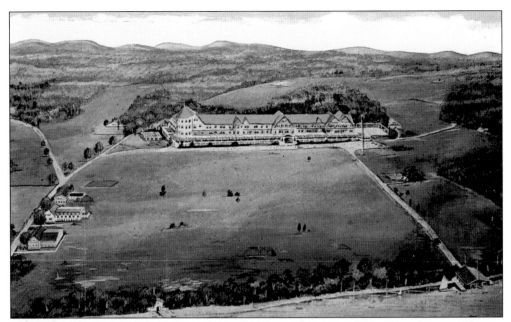

The Belgrade was a large and fancy resort hotel catering to wealthy clientele, as well as to anglers. Built in 1903, it was expanded c. 1910 and was a favorite convention center. The 100-room facility burned in 1956.

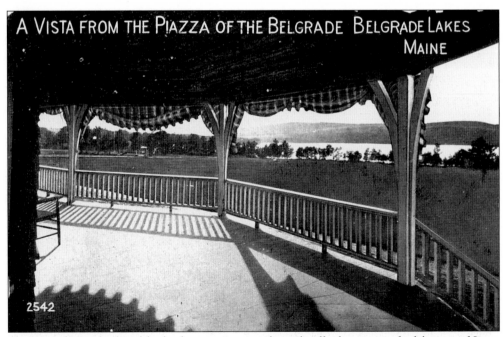

As shown here, the hotel had a huge wraparound porch affording a wonderful view of Long Lake and overlooking the golf course. Several lakes in this area produced excellent fishing for trout, salmon, and bass.

Castle Island Camps are named after the Castle family, who began the resort in the mid-1920s. It is still owned by the Castles, and it consists of 12 cabins on Long Pond.

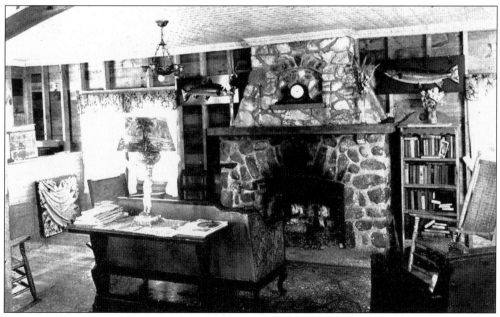

This interior photograph of one of the buildings at Castle Camps shows an impressive fireplace and trophy fish.

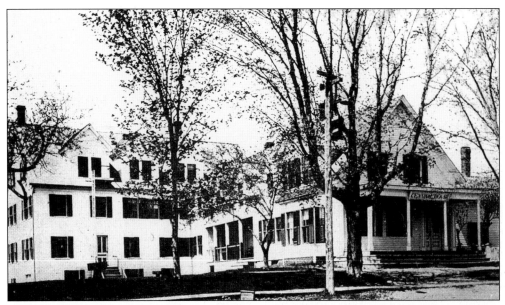

The Central House, also located on Long Pond, could accommodate 100 guests. Many of them came to fish.

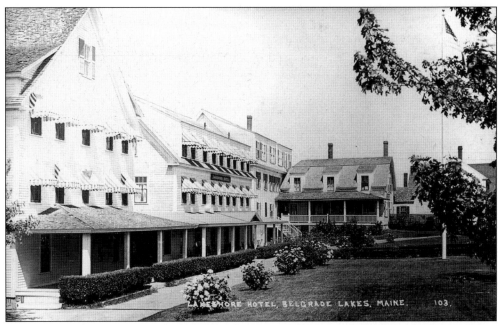

Lakeshore Hotel was another large well-appointed establishment in the Lakes Region.

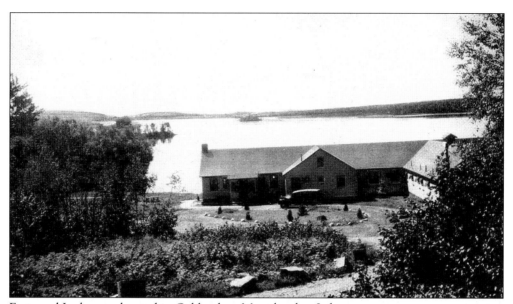

Eastwood Lodge was located in Oakland on Messalonskee Lake.

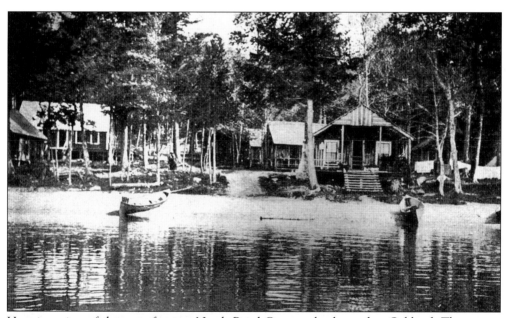

Here is a view of the waterfront at North Pond Camps, also located at Oakland. There were 22 individual cabins here along with a central dining hall, which could seat 140 people.

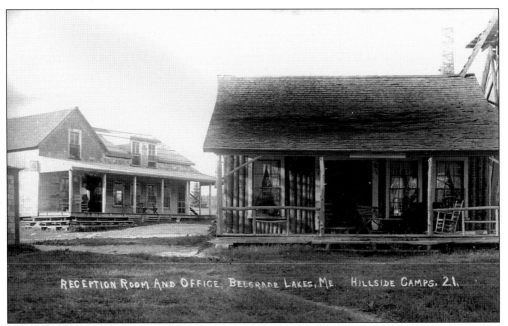

RECEPTION ROOM AND OFFICE, BELGRADE LAKES, ME. HILLSIDE CAMPS, 21.

The Hillside Camps catered heavily to fisherman who took advantage of the excellent possibilities in the surrounding lakes. Shown here are the reception room and office.

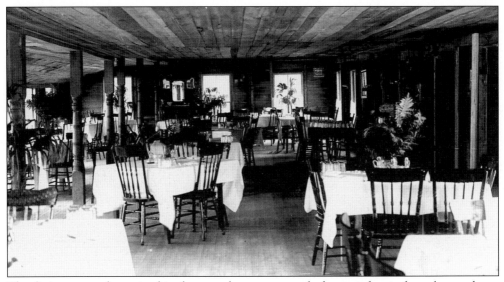

The dining room, shown in this photograph, was extremely fancy and served regular meals.

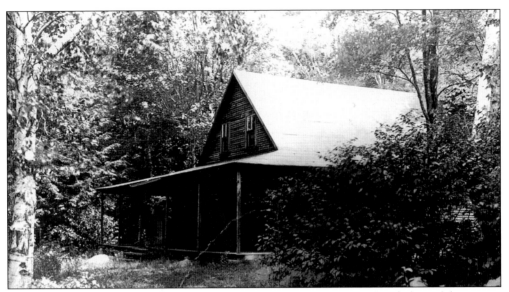

This is one of the individual cottages at Hillside Camps. Most cottages at lodges of this nature had names, and this particular cabin was called Trail's End.

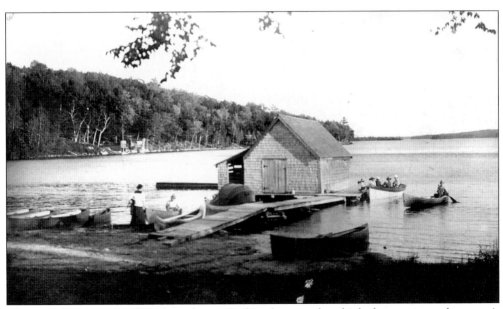

The waterfront area at Hillside is shown in this photograph, which demonstrates the resort's seriousness about boating and fishing.

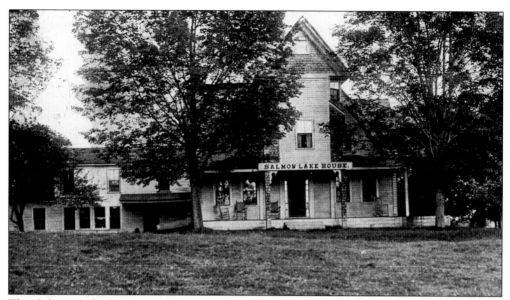

The Salmon Lake House was located in North Belgrade where the waters of Salmon Lake empty into Great Lake. It was open year-round and was a favorite rendezvous for hayride parties from Waterville.

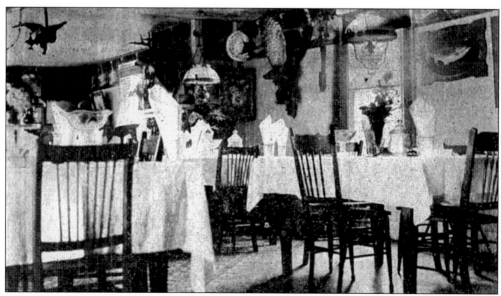

The dining room at the Salmon Lake House is shown here. Typically adorned with beautiful linens, the room is also decorated with appropriate trophies.

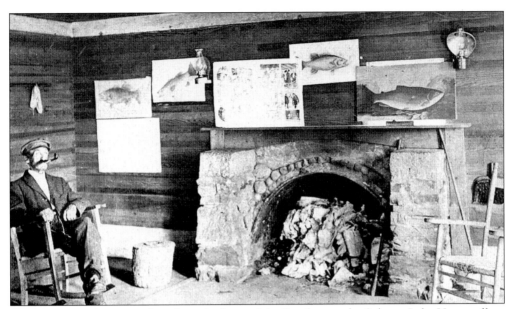

A patron, or perhaps a guide, relaxes in front of the fireplace at the Salmon Lake House office. Many trophy fish and memorabilia adorn the walls.

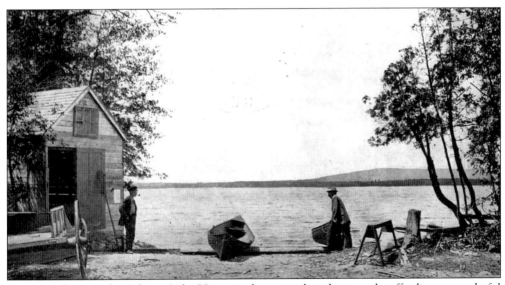

The waterfront at the Salmon Lake House is shown in this photograph, affording a wonderful view of Great Pond.

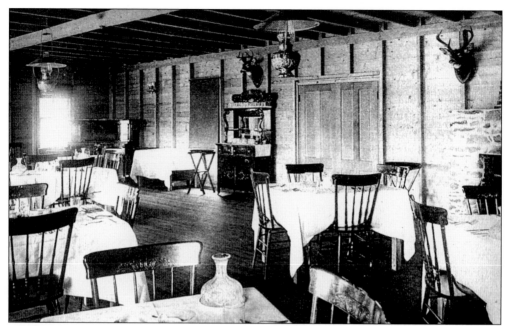

Another establishment in the Belgrade area was the Alexander Camps, represented here with a photograph of their dining area.

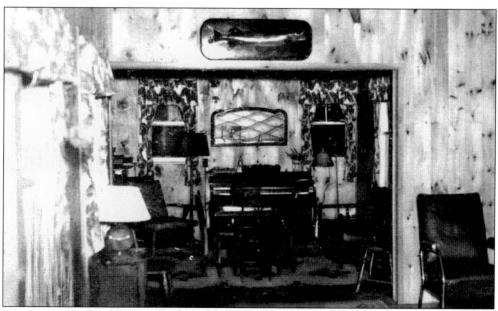

Snug Harbor Camps were located at North Belgrade. This photograph shows a section of the central living room.

Eight
THE RANGELEY LAKES REGION

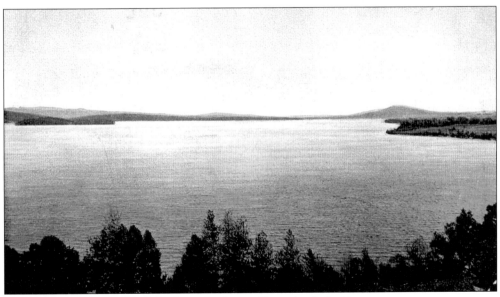

This is a view of Rangeley Lake from the former Rangeley Lake House.

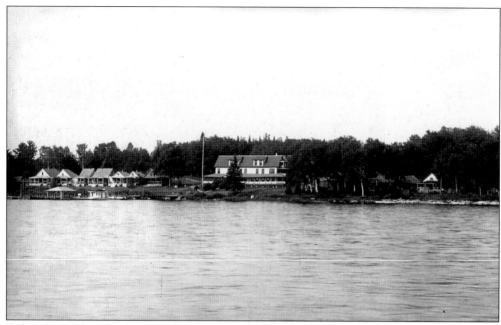

Coburn's Angler's Retreat was first established *c.* 1860 at Middle Dam at Lower Richardson Lake. The early guest camps were constructed in the late 1870s.

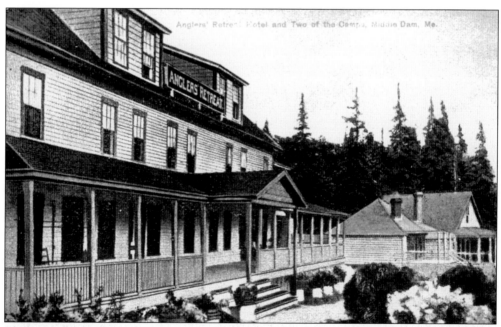

This was a formidable establishment, as can be seen here. At one time, there were 20 cabins located here. Capt. Ed Coburn operated the camps from *c.* 1893 to 1943, and he changed the name to Lakewood Camps in 1909. In 1957, a fire destroyed the main lodge, several buildings, and cabins, leaving 13 cottages remaining. They continue to operate today.

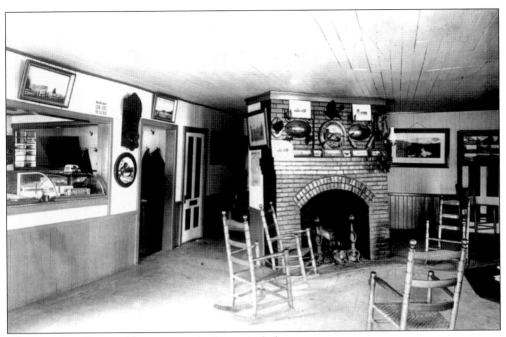

This was the office and lounge area in the main lodge.

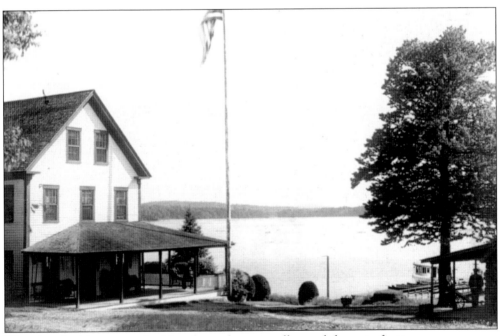

This view, looking across the lake, shows the main office and the waterfront.

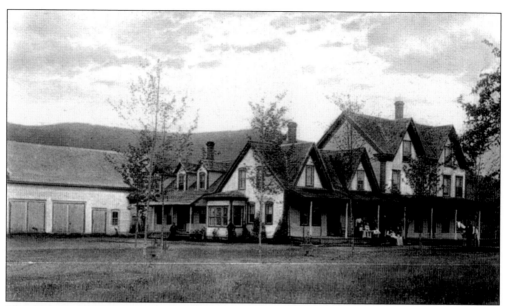

The Aziscoos House was located in Wilson's Mills and was originally built *c.* 1830 as a private home. Around 1890, it was opened as a hotel, and in 1958, it was called the Aziscohos Inn and Cabins. It was sold in 1974, when it again became a private residence. This lodge was a favorite stopping place for travelers from Umbagog Lake to Aziscoos Lake. Sportsmen fishing the nearby waters also frequented it.

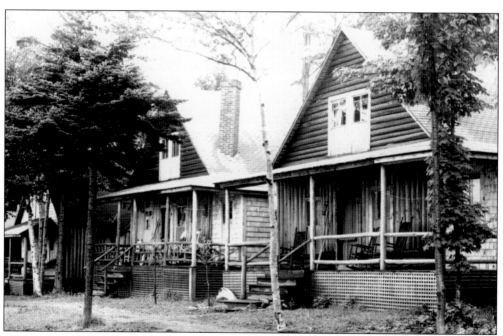

Bald Mountain Camps were located on the east shore of Mooselookmeguntic Lake. The camps were built in 1897 and could accommodate 40 people. In 1914, fire destroyed several of the camps, which were replaced by two new camps and a dining hall.

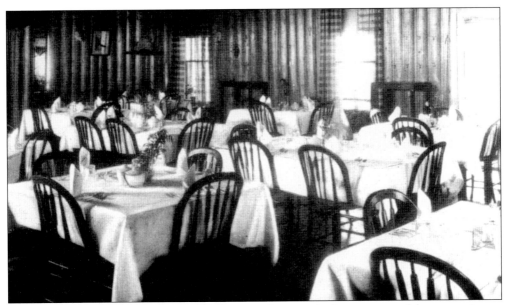

Shown here is the dining hall at Bald Mountain Camps, which was a very elaborate setting.

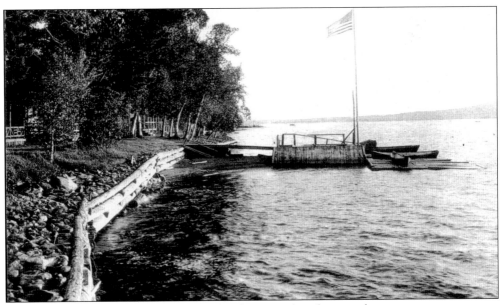

The waterfront of Bald Mountain Camps is shown in this photograph.

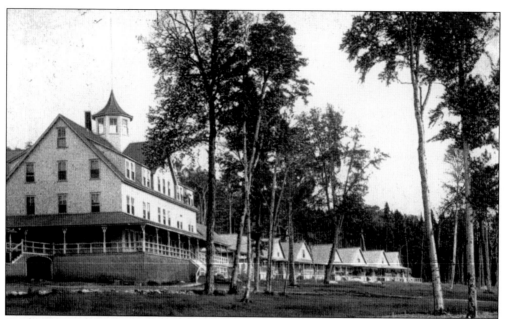

Capt. Fred C. Barker began his career as a guide, established his own steamboat operation, and built a hotel and some 50 log cabins. He opened the Barker Hotel, shown here, in 1902 with 35 rooms and a dining area. He died in 1937, and his descendants kept the hotel open with a small clientele until 1966, when the hotel was closed. It was demolished the following year.

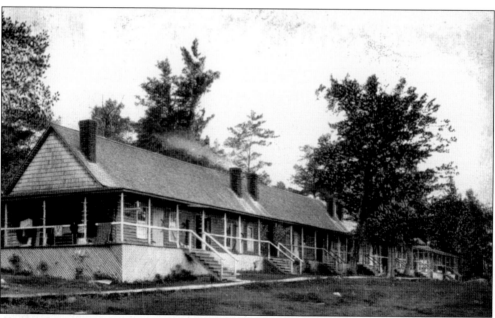

The Birches were also built by Captain Barker on Students Island. In 1888, the resort consisted of the main lodge with an office and dining room, a guide's camp, and another cottage. He continued to build camps, and by 1925 there were 28 camps. That year the main lodge and 11 camps burned. Five of the remaining camps were hauled across the ice to his Barker location, and the rest were left where they were.

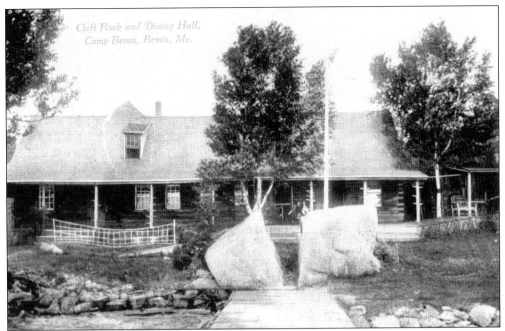

Camp Bemis was located at the lower end of Mooselookmeguntic Lake at the mouth of Bemis Stream. In 1880, the existing camps were purchased by Fred C. Barker, who tore down the old camps and constructed Camp Bemis. The dining hall, shown here, was called Cleft Rock Hall, and by 1884, there were nine log cabins and a six-room house that could accommodate 30 guests. The establishment went through a series of ownerships, and in 1970, the lodge was struck by lightning and burned.

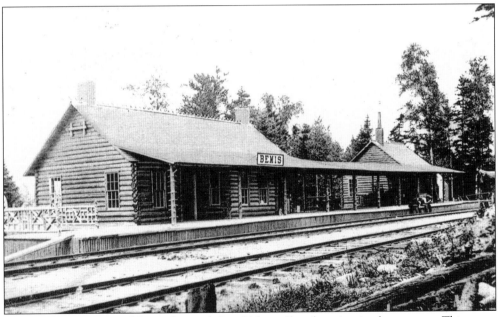

The small community of Bemis boasted the old log railroad station in the country. This was a major point for Captain Barker's activities. It eventually succumbed to fire.

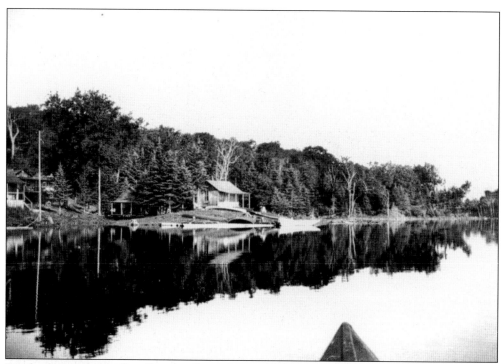

Bosebuck Camps, which still exist today, were established c. 1909 on the west shore of Aziscoos Lake. Perley Flint was involved with the resort during the early years and operated the camps until his death in 1956.

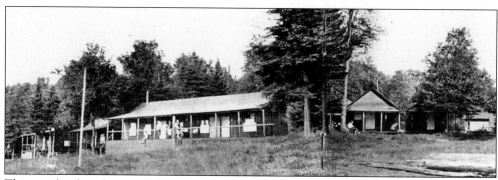

This area has long been well known for outstanding brook trout fishing, as well as hunting.

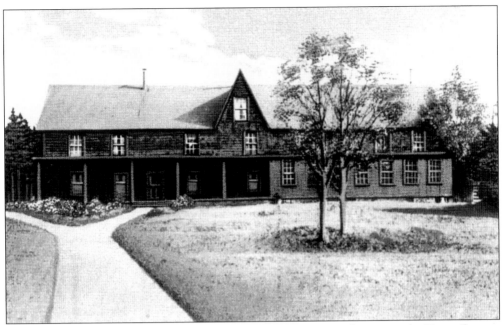

Kennebago Lake Camps were first built c. 1871. In 1884, it was known as the Forest Retreat House with 20 rooms and a long porch. Cabins were later added, and by 1912, they numbered 13 plus the 10-room main lodge. The camps were sold off, and in 1972, the contents of the lodge were sold. The main building was razed in 1974.

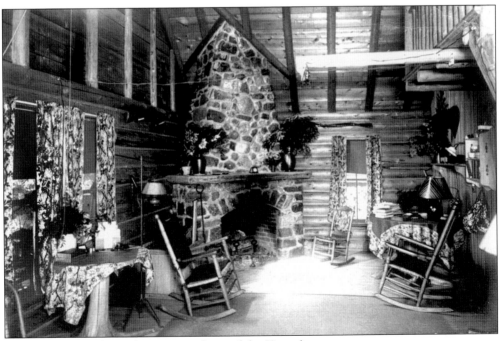

This photograph shows the interior of one of the Kennebago camps.

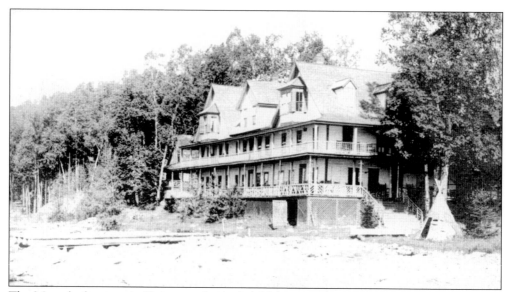

The Mooselookmeguntic House was located at Haines Landing and was established in 1877. After the beginning of the 20th century, cabins were added. The hotel, containing 20 rooms, burned to the ground in 1958, at which time the 27 cottages were converted to housekeeping. In 1986, the property was subdivided and the camps sold individually.

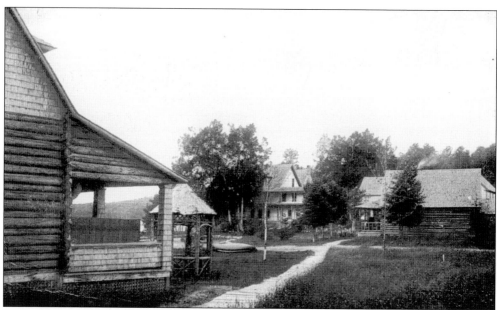

Shown here are a few of the cabins at the Haines Landing location.

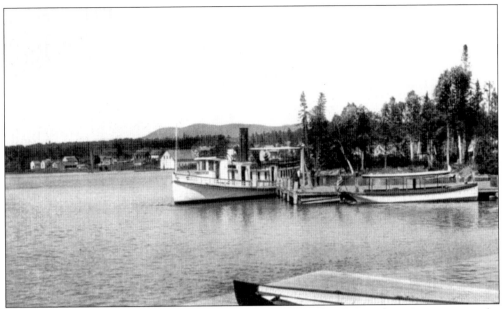

When in full operation, Haines Landing accommodated the larger steamboats operating on the lake, as shown in this photograph.

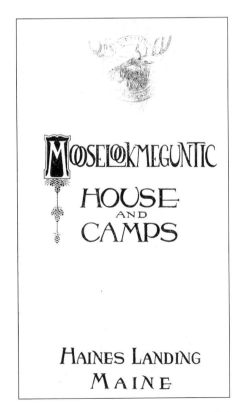

MOOSELOOKMEGUNTIC

HOUSE
AND
CAMPS

HAINES LANDING
MAINE

This is the cover of a small, elaborate brochure produced by the Mooselookmeguntic House and Camps.

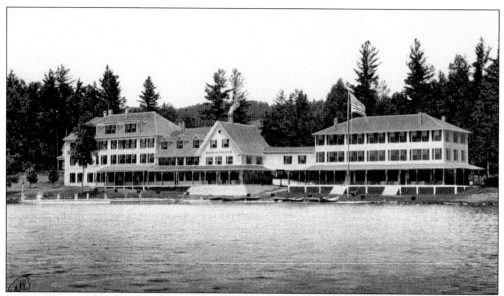

The Mountain View House was opened in 1878. It was expanded with the addition of a three-story annex with a fireplace that fit a five-foot log. A 12-foot piazza was built on three sides. By 1900, the lodge could accommodate 85 guests. After a series of ownerships, the main building was razed in 1952. The annex was destroyed by fire in 1956, and eventually the remaining cottages were subdivided and sold individually.

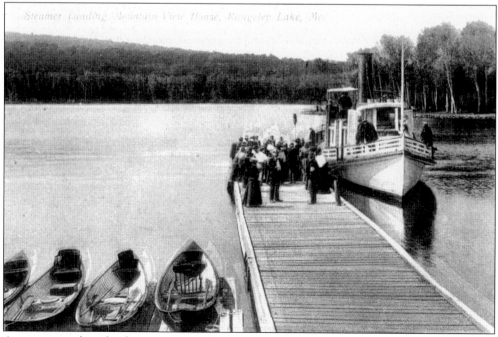

A major steamboat landing once existed at this location, as this photograph shows.

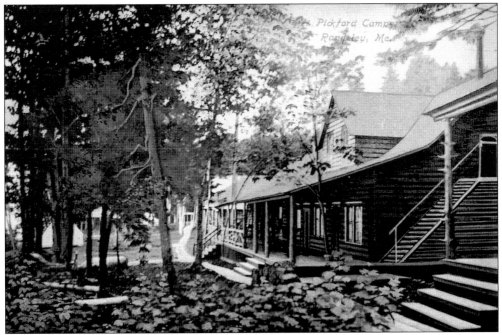

Pickford Camps opened in 1900 with a main lodge containing an office and a dining room, along with four log cabins. The camps went through a series of ownerships, and they were converted to housekeeping camps in 1959. By 1962, there were 24 cottages, all of which closed in 1972 and were auctioned with the camps sold individually.

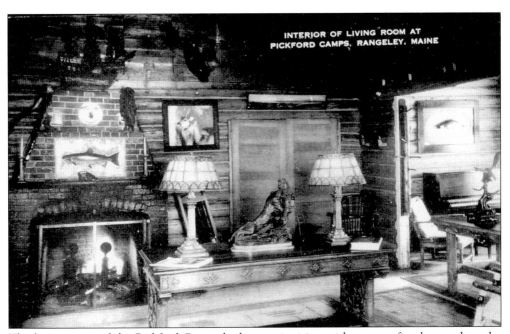

The living room of the Pickford Camps looks very inviting with a warm fireplace and trophy fish mounts.

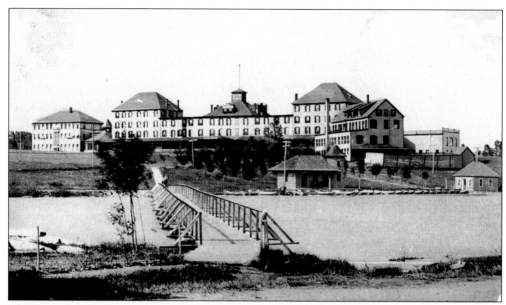

The Rangeley Region's most upscale establishment was the Rangeley Lake House. Like the Mount Kineo at Moosehead, the Rangeley Lake House had a nearby railroad station and offered a wide variety of activities to their patrons. The original house was built in 1877, containing three and a half stories and 14 rooms. Over the years it was expanded, and an annex was added and an elevator installed. Around 1958, the buildings were demolished and the property subdivided.

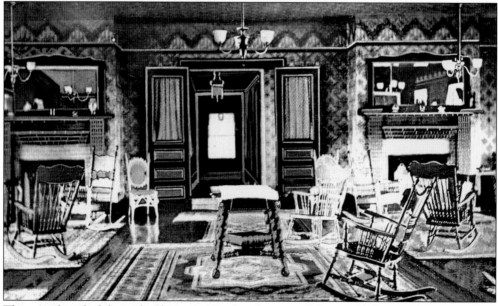

This postal card of the parlor demonstrates the elegance of this establishment.

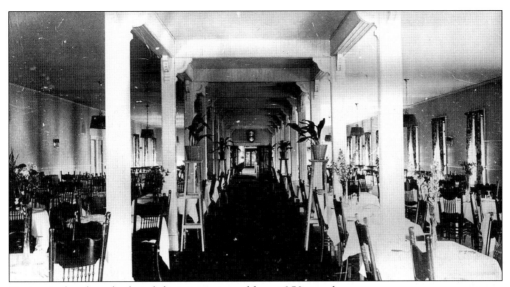

During its heyday, the hotel dining room could seat 350 people.

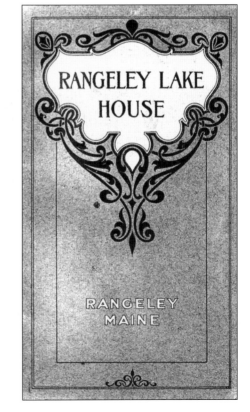

This is the cover of the small brochure produced by the Rangeley Lake House containing a description of the premises and photographs. Many of the larger, fancier establishments produced such brochures.

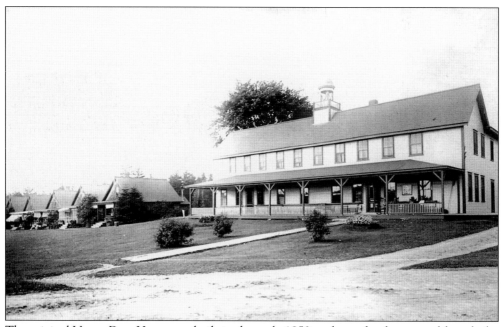

The original Upper Dam House was built in the early 1850s to house lumbermen, although the house did accommodate fishermen coming to fish the famous Upper Dam Pool at the outlet of Mooselookmeguntic Lake. The next lodge was built in the mid-1880s and another constructed sometime later, which contained a 10-foot-wide fireplace and a dining room. It closed in 1952. The main house was torn down in 1958, and the camps were leased to individuals as they are today.

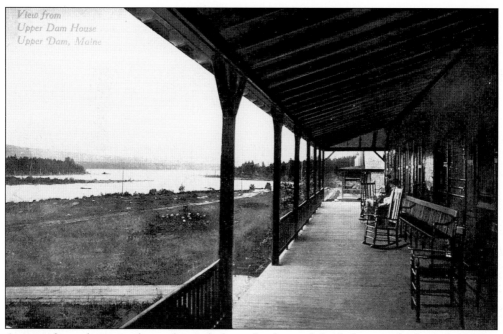

A magnificent large porch was located along the front of the lodge, overlooking the Upper Dam Pool.

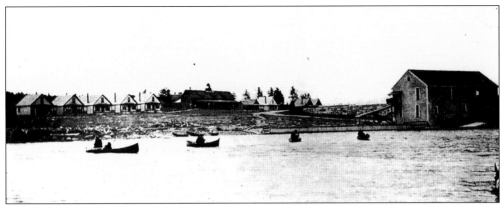

Here, several fisherman are trying their luck at the pool. The dam can be seen at the right of the picture, where the Upper Dam House and its adjoining cabins can be seen in the background.

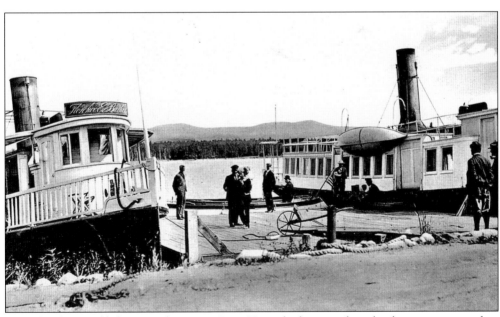

As with other establishments, the Upper Dam House had its own boat landing to accommodate the steamers carrying passengers from place to place. This was located on the rear side of the dam.

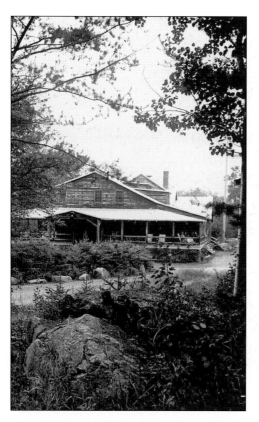

York's Log Village consisted of a main lodge, shown here, and eventually 30 individual camps. They were first constructed in 1889 and expanded over the years. J. Lewis York was the principal operator for many years until he died in 1942. His son took over and operated the establishment until it closed. In 1966, the kitchen was discontinued, and in 1967, several of the camps were sold.

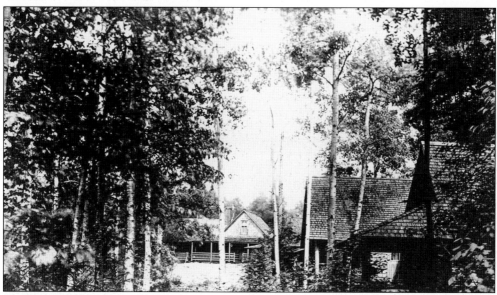

The lodge and camps were located on Loon Lake, north of Rangeley Village, and could at one time accommodate 100 people. They had the distinction in 1938 of being the first public camps in the area to have telephone service in every cottage.

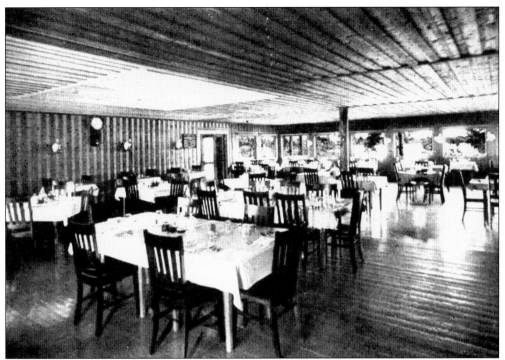

The dining room at this establishment was quite large and was supplied with dairy products from York's farm and vegetables from nearby farms.

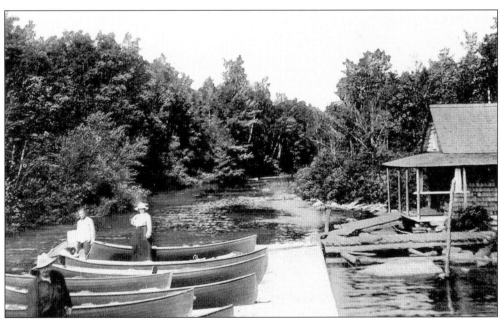

While York's offered a variety of activities, boating and fishing were extremely popular. This is a scene at their boathouse.

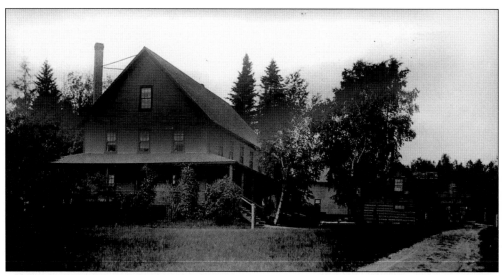

Oquossoc Angling Association is an example of a private lodge, and it is located in Oquossoc at Indian Rock. The camps were built in the 1860s and incorporated as an association in 1870. In the 1890s, members began building their own cabins, and today there are 24 private cottages, a main building, and a caretaker's cabin.

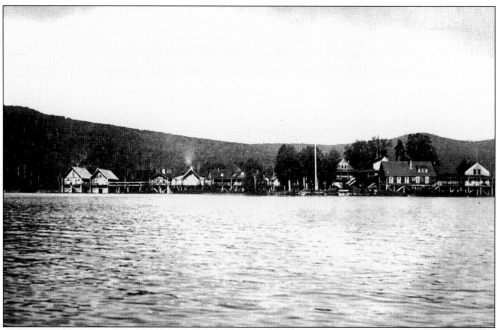

The Parmachenee Club was established in 1890 as a private club and operated until 1935, when it was opened to the public. In 1945, the establishment was sold to the Brown Paper Company, and it again became a private club for their employees and guests. In 1955, President Eisenhower visited here and fished nearby water.

Nine

THE SEBAGO LAKE REGION

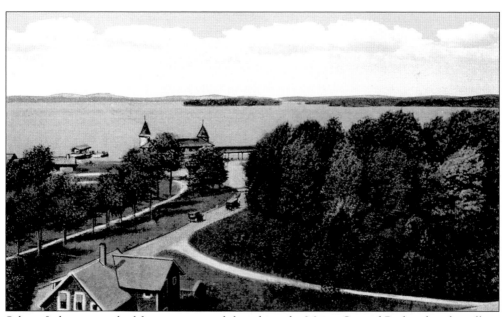

Sebago Lake was reached from points south by taking the Maine Central Railroad to the village of Sebago Lake at the south end of lake. Parties boarded steamers at the dock shown here to travel to other parts of the lake, or through a series of locks to other lakes beyond.

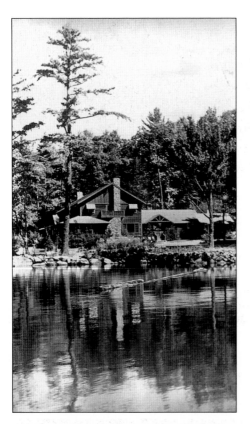

One of the establishments beyond Sebago Lake was Brown's Camps, later becoming known as Severance Lodge, located on Lake Kezar in Center Lovell. Benjamin E. Brown built the first camp, called the Pioneer, in 1896, after which he built the main lodge and several additional cabins. When Brown's Camps burned in 1934, the property was bought by the Severances and developed into a lodge once again. Severance Lodge is now a private club, and the cottages are owned individually.

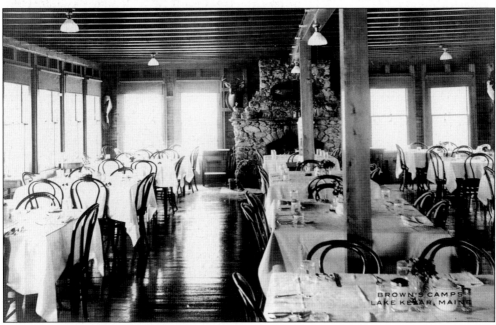

The main lodge housed the dining room, which contained a large fireplace. Food was served fresh here daily from the Portland markets.

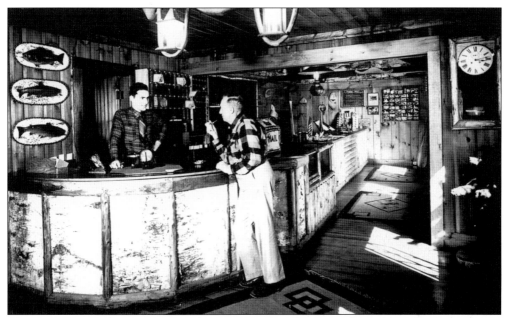

The Severance Lodge also contained an office and trading post, shown here.

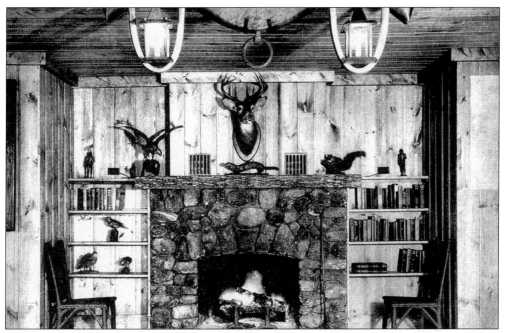

This is an interior image of one of the cottages. Kezar Lake is 10 miles long and from one-half to two miles wide. It is 150 feet deep, and for years it has produced exceptional fishing for landlocked salmon and bass.

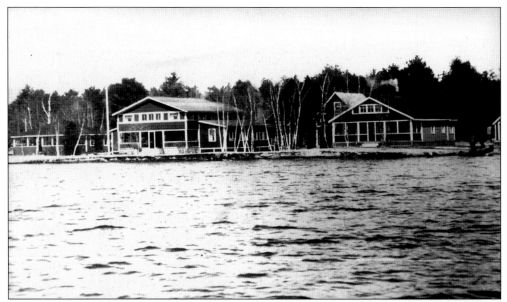

Once known as Livermore Camps, the Thompson Camps were located at the north end of Sebago Lake at Naples. They were well known during the glory days of salmon fishing on Sebago Lake, home of the world's record landlocked salmon.

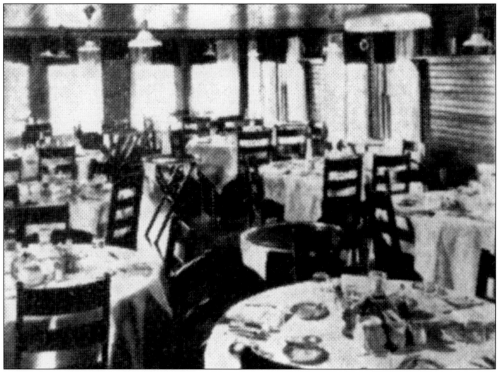

An elegant dining area at Thompson's is shown in this photograph.

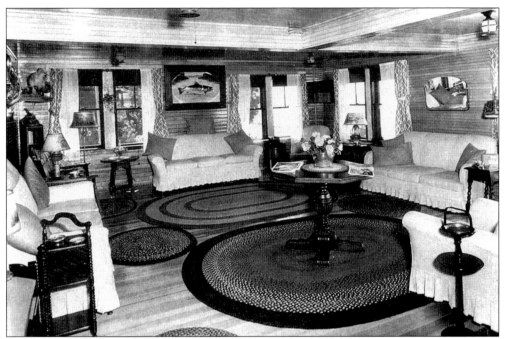

The lounge area at Thompson's appears to be a very comfortable place to relax. Without doubt, a great number of fishing stories were told here.

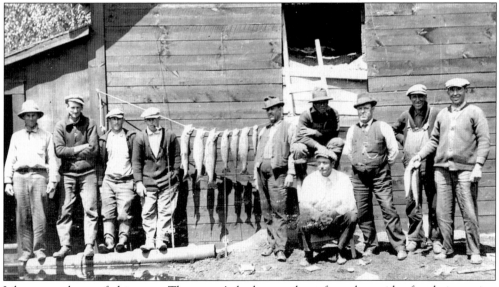

Like most places of this type, Thompson's had a number of regular guides for their parties. Shown here is a group of guides with some very nice salmon.

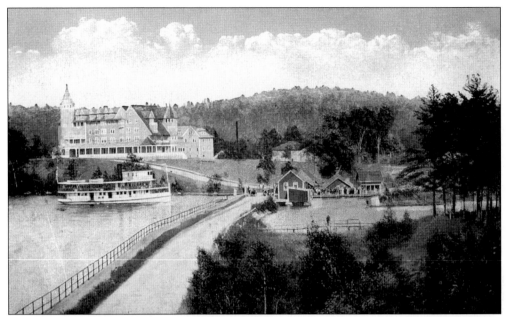

In Naples, at the north end of the lake, were the steamboat landing and the Bay of Naples Hotel, later known as the Bay of Naples Inn. Complete with elevator, the hotel opened in 1898 at a cost of $30,000. Fifteen-foot piazzas practically encircled the building, and the huge ornate fireplace in the lounge was considered to be the largest in this part of the country. Part of the interior was finished in a rare cypress wood, imported from South America. The hotel was demolished in 1964.

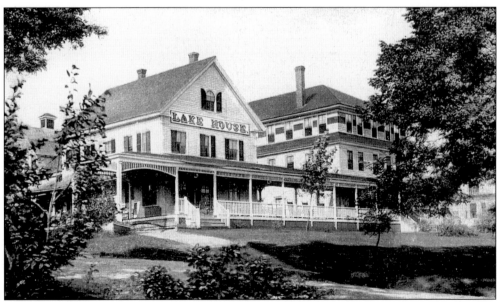

Another early Naples inn was the Lake House, shown here.

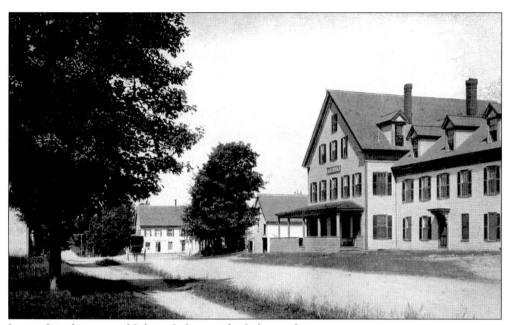

Located in the town of Sebago Lake was the Lakewood.

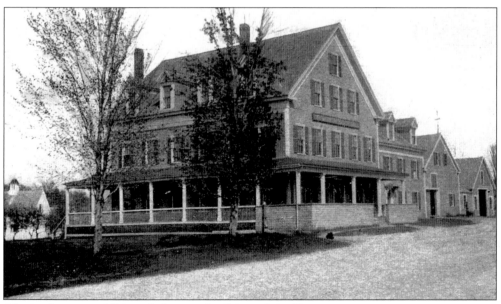

Also in the town of Sebago Lake was the Sebago Lake House.

BIBLIOGRAPHY

Arlen, Alice. *In the Maine Woods*. Woodstock, Vermont: the Countryman Press, 1998.

Bangor and Aroostook Railroad. *In the Maine Woods*. Various articles and advertisements from various years.

Barnes, Diane and Jack. *The Sebago Lake Area*. Dover, New Hampshire: Arcadia Publishing, 1996.

Blanchard, Dorothy A. *Old Sebec Lake*. Dover, New Hampshire: Arcadia Publishing, 1997.

Duplessis, Shirley. *Hidden in the Woods: The Story of Kokad-jo*. Greenville, Maine: Moosehead Communications, 1997.

Jackman Bicentennial Book Committee. *The History of Moose River Valley*. K. J. Printing.

Merrill, Daphne Winslow. *The Lakes of Maine*. Rockland, Maine: Courier-Gazette, 1973.

Palmer, R. Donald. *Rangeley Lakes Region*. Charleston, South Carolina: Arcadia Publishing, 2004.

Priest, Gary N. *History of Rangeley Hotels and Camps*. Rangeley, Maine: Gary Priest, 2003.

Wilson, Donald A. *Glimpses of Maine's Angling Past*. Charleston, South Carolina: Arcadia Publishing, 2000.